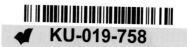
75 years of giving THE FRIENDS OF THE NATIONAL COLLECTIONS OF IRELAND *Works of*

art donated by the Friends to the Public Collections of Ireland

THE FRIENDS OF THE NATIONAL COLLECTIONS OF IRELAND

c/o the Hugh Lane Municipal Gallery of Modern Art, Charlemont House, Parnell Square North, Dublin 1

This catalogue was published by The Friends of the National Collections of Ireland on the occasion of the 75th Anniversary Exhibition in August 1999 held in the RHA Gallagher Gallery and the Hugh Lane Municipal Gallery of Modern Art, Dublin.

British Library Cataloguing in publication Data available.

ISBN 0 900903 94 5

Edited by Harold Clarke and Aidan O'Flanagan
Designed and Produced by Creative Inputs
Colour Reproduction and Printing by Nicholson & Bass

Front Cover details from
PORTRAITS OF LADY CATHERINE AND LADY CHARLOTTE TALBOT John Michael Wright
PORTRAITS OF BARRY & BURKE IN THE CHARACTERS OF ULYSSES AND
HIS COMPANION FLEEING FROM THE CAVE OF POLYPHEMUS James Barry
THE VIOLINIST Derek Hill
PORTRAIT OF SARAH PURSER Mary Swanzy
SCENE FROM THE MARRIAGE AT CANA IN GAILEE Sir Stanley Spencer

Back Cover details from
RINGED LILY Ivon Hitchens
GEORGE III OBLONG MILK JUG William Heyland
SHAKYAMUNI BUDDHA Romio Shrestha
BOULEVARD DE CLICHY Pierre Bonnard

CONTENTS

ACKNOWLEDGMENTS

This book was published by THE FRIENDS OF THE NATIONAL COLLECTIONS OF IRELAND *on the occasion of* THE EXHIBITION HELD ON 6-29TH AUGUST 1999 TO CELEBRATE THE 75TH ANNIVERSARY OF ITS FOUNDATION.

We acknowledge the support of the following institutions and people, without which the exhibition could not have taken place:-
The Department of Arts, Heritage, Gaeltacht and the Islands; Dr. A. J. F. O'Reilly; The Heritage Council; The Ireland Funds; Ronan Group; James Adam & Sons; School of Irish Studies Foundation; First Active plc; Coyle Hamilton; Dublin Corporation; RHA Gallagher Gallery.

We wish to thank the following members of the Friends of the National Collections of Ireland and others who contributed so generously towards the mounting of the exhibition:-
Ms. Nicole M.F. Arnould; Lady Blunden; Mr. & Mrs. Michael Boyd; Mr. & Mrs. P.J. Brennan; Mr. & Mrs. Stephen Brennan; Mr. Frank X. Buckley; Dr. Henry Burke; Ms. Marie Burke; Mr. Fionnbar Callanan; Mrs. Agnes Cassidy; The City of Cork V.E.C.; Mr. W. Harold Clarke; Sir Marc Cochrane; Mrs. Jane Collins; Mr & Mrs John Connelly; Dr. John G. Cooney; Mr. Brian Coyle, F.R.I.C.S.; Mr. David Craig; Antoin Daltun P.A; Mr. & Mrs. Hugh Doran; Mrs. Ida Dover; Mr. & Mrs. Brian Doyle; Dr. & Mrs. M.I. Drury; Desmond FitzGerald; Mrs. Pauline Fitzpatrick; Dr. & Mrs. H.J. Galvin; Mrs. M.L. Gillespie; The Hon. Desmond Guinness; Mr. & Mrs. D.P. Hanly; Mr. Aidan Heavey; Mr. & Mrs. W.P. Hederman; Dr. Derek Hill; Mr. & Mrs. Philip Jacob; Dr. Eileen Kane; Mrs. Delphine Kelly; Mrs. Joan Lawlor; Ms. Bernadette Lynch; Mrs. Cróine Magan; Mr. Michael A. Mallin; Mrs. Avice Maughan; Dr. Joan M. McCarthy; Mrs. Maura C. McDonnell; Mr. Joseph McKinley; Prof. & Mrs. Risteard Mulcahy; Mr. & Mrs. Martin Naughton; Donal agus Anrai O'Braonain; Mrs. Ros O'Brien; Dr. Brigid O'Connell; Mr & Mrs. Brian J. O'Connor; Ms. Geraldine O'Connor; Mrs. R.M. O'Hanlon; Mrs. Elizabeth O'Kelly; Mr. Brendan O'Regan; Dr. & Mrs. A.J.F. O'Reilly; Mrs. Mafra O'Reilly; Mr. Kenneth P. O'Reilly-Hyland; Mr. Harry Poole; Mr. & Mr. Michael Purser; Dr. & Mrs. Raymond Rees; Mr. Nicholas K. Robinson; Mr. John Ronan; Mr. & Mrs. John Ross; Mr. Noel Ross; Mr. Matthew Russell; Dr. Thomas Ryan; Mr. Eoin Ryan; Ms. Una Scott; Mr. & Mrs. Cornelius F. Smith; Mr. & Mrs. T.C. Smyth; Dr. & Mrs. Michael Solomons; Ms. Mary Spollen; Mr. Donal Tinney; Mr. Jeremy Williams; Miss Jane Williams; Dr. Michael Wynne; Ms. Caitroina Ni Shuilleabhain; Christies; Irish Antique Dealers Association; Sothebys; The Kennedy Gallery.

Brian J. O'Connor
President of the Friends of the National Collections of Ireland

THE FRIENDS OF THE NATIONAL COLLECTIONS OF IRELAND *are delighted to mark the 75th anniversary of* THEIR FOUNDATION BY HOLDING THIS UNIQUE PUBLIC EXHIBITION *comprising a selection of art and artefacts*

which have been donated to galleries and museums throughout the whole of Ireland. The Friends are grateful to them for lending back the works which constitute this exhibition. The Friends also wish to thank those who have given so generously of their time and expertise in the planning and organisation of the exhibition. I would like in particular to record the contribution of our treasurer, Aidan O'Flanagan, together with the other members of our Councils exhibition sub-committee, Dr. Thomas Ryan PPRHA and Dr. James White.

The mounting of the exhibition and the production of this catalogue (including list of donations) have been expensive undertakings. We wish to thank those who contributed towards the cost, including our own members and, in particular those who are listed in this publication.

The RHA Gallagher Gallery has been most helpful in providing the main venue for the exhibition. It is appropriate that part of the exhibition should take place at the Hugh Lane Municipal Gallery of Modern Art, Parnell Square, in view of the prominent role played by our founder, Sarah Purser in obtaining Charlemont House for Dublin's Municipal Gallery. Many of the finest works in that collection were donated by the Friends over the years.

Although the works of major artists have grown increasingly expensive and are therefore more difficult to acquire, the Friends have a significant contribution to make these days by assisting in the purchase of works by less well known artists for Irish museums and galleries. The Friends have always been entirely dependent on members' subscriptions, proceeds of outings, gifts and bequests. It is our hope that all those who have enjoyed this interesting exhibition will be encouraged to join the Friends to enable us to continue the work as set out in our constitution of 1924 of "securing by purchase, gift or bequest of works of art and objects of historic interest or importance for the national and public collections of Ireland".

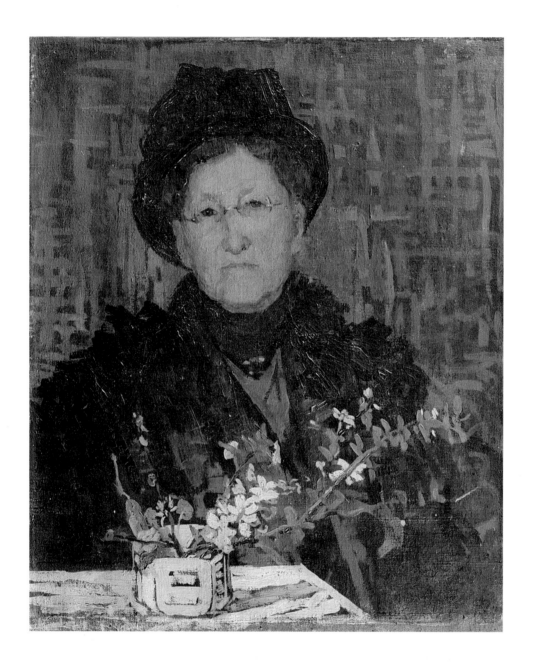

PORTRAIT OF SARAH PURSER | Mary Swanzy (1882-1978)

Hugh Lane Municipal Gallery of Modern Art, Dublin

Nicola Gordon Bowe

THE SOCIETY OF THE FRIENDS OF THE NATIONAL COLLECTIONS OF IRELAND *was founded by Sarah Purser on* THURSDAY 14TH FEBRUARY 1924, AT AN INAUGURAL MEETING HELD AT THE ROYAL IRISH ACADEMY IN DUBLIN.

Purser (1848-1943)[1], an established painter and leading figure in Dublin's cultural revival in the first thirty or so years of this century, had already founded *An Túr Gloine* (The Tower of Glass)[2], the pioneering stained glass co-operative workshop, in 1903. Their initial stated purpose was "to secure works of art and objects of historic interest or importance for the national or public collections of Ireland by purchase, gift or bequest, and to further their interest in other analogous or incidental ways"[3]. They were only too aware that "Public collections do not thrive in modern conditions if supported only by the State" and that at this crucial stage in the emergence of the new Free State "to buy successfully requires ample resources and great freedom of action. The modern State is not in a position to concede either, and the great European and American Collections depend for their development in growing measure upon the collaboration of the private citizen …[whose] taste and generosity" have resulted in collections "eminent precisely in the degree in which they attract … enlightened benefactors. The names of William Dargan and Sir Hugh Lane forbid one thinking that such princely benefactors are impossible in modern Ireland; but they are of necessity rare, and even if they are less infrequent, the needs of our National Collections, like others abroad, make continuous corporate assistance desirable". This, they felt, was a propitious moment "to group into a Society", similar to those already established in Paris, Amsterdam, Berlin and London, Irish citizens "who have a care for our public collections and value the prestige which they confer upon our country"[4].

1. See John O'Grady, *The Life and Work of Sarah Purser,* Dublin 1996. Ph.D. Thesis, National University of Ireland 1974.

2. Nicola Gordon Bowe, 'Early Twentieth Century Irish Stained Glass in Context', in N. Gordon Bowe, D. Caron and M. Wynne, *A Gazetteer of Irish Stained Glass,* Dublin 1998. A recent presentation, through the F.N.C.I. by Professor and Mrs Seán Purser of Wilhelmina Geddes' watercolour illustration of *Cinderella Dressing her Ugly Sister* (1910), marks the acquisition of the work which led Purser to invite Geddes to join An Túr Gloine and become a key figure in twentieth century stained glass.

3. 1st Annual Report, The Friends of the National Collections of Ireland, 1924 - 5, rule 2.

4. Ibid.

In 1907 Sir Hugh Lane had written in his Preface to the first (and only) *Illustrated Catalogue* to the collection of the Municipal Gallery of Modern Art in its original home in Harcourt Street:[5] "Till to-day Ireland was the only country in Europe that had no Gallery of Modern Art. There is not even a single accessible private collection of Modern Pictures in this country. That reproach is now removed" – namely by his magnificent bequest to the City of Dublin. He added, "The National Gallery of Ireland has a fine collection of works by the old masters, yet Sir Walter Armstrong himself says: 'I would place the importance of a modern Gallery even before that of a National Gallery'. To those actively engaged in Art this must be so, as it is his contemporaries that teach the student most, their successes that inspire him, for their problems are akin."

At an adjourned meeting two weeks after the Society's formation, the Rules of the Society were adopted and its first Council and Officers elected. The Earl of Granard was elected its first President and its Vice Presidents were Sarah Purser R.H.A., Dermod O'Brien P.R.H.A., W.G. Strickland M.R.I.A., the art historian, George 'AE' Russell, painter, writer and visionary reformer, Sir Robert Woods F.R.C.I., the surgeon and Sir John Leslie, Bart. The original list of members represented distinguished men and women from public life in Ireland, including Mr. and Mrs. George Bernard Shaw, Mrs. W.B. Yeats and Oliver St. John Gogarty. By their first A.G.M. on March 25th 1925, held at Dermod O'Brien house at 65 Fitzwilliam Square, they had secured a small supportive core of 112 members at a guinea apiece, and three bequests: a miniature of a Mrs. Coote by the eighteenth century Irish miniaturist John Comerford (for the National Gallery), a nineteenth century flowerpiece by Quost (for the Municipal Gallery) and a sixteenth century engraved powder-horn (for the National Museum).

Thomas Bodkin,[6] a founder Council member, who became the Director of the National Gallery of Ireland in 1927, wrote that under Sarah Purser's leadership the Society "soon came to the conclusion that they should occupy themselves largely in the endeavour to secure a return of the Lane Conditional Gift of Modern Continental Pictures to Dublin" [7]. A British Government Commission Report of 1924 had recently found "that Sir Hugh Lane, when he signed the codicil of the 3rd February 1915, thought he was making a legal disposition" although speculated how he might have destroyed this had he seen London's new Tate Gallery extension[8]. On May 18th 1924, Sarah Cecilia Harrison,[9] the painter,

5. The catalogue was reprinted with a new preface, 'The Municipal Gallery, Sir Hugh Lane and the Friends' by James White, by the F.N.C.I. in 1984 to commemorate their 60th anniversary.

6. See Homan Potterton, *Illustrated Summary Catalogue of Paintings,* National Gallery of Ireland, Dublin 1981, Introduction, pp. xxxiii-iv.

7. Thomas Bodkin, *Hugh Lane and his Pictures,* Dublin 1956, pp. 62 - 3 and for the full story of the protracted affair. See also James White, op.cit, n.p.

8. Manifesto of the F.N.C.I., May 1928.

9. See *Irish Women Artists from the eighteenth Century to the Present Day,* National Gallery of Ireland, Dublin 1987, pp. 107 - 8, p. 166; also Hilary Pyle, *Irish Art 1900 - 1950,* Cork 1975, pp. 32 - 3.

confidante of Lane and annotator of the 1908 Municipal Gallery catalogue, submitted a full statement[10] to the Dublin Municipal Council who were to implement the formal request for the immediate return to Dublin of the 39 pictures known as the Lane Bequest to the English National Gallery[11]. In this, she methodically set out the situation to date, but referred to the dubious authenticity of the 1915 unattested codicil to what she saw as Sir Hugh Lane's earlier equally questionable will of 1913, which would revoke his bequest of these pictures to London in favour of Dublin. This, perversely, she refuted, documenting Lane's pressing last wishes expressed to her and Alderman Kelly in February 1915 before his ill-fated departure on the *Lusitania* sailing to America: "If Dublin would build a gallery for them, they had the first claim, if not, the Gallery of a Modern Continental Art in London." The raging controversy was brought to a head when Lord Duveen's extension to the Tate Gallery, opened by King George V on June 26th 1926, featured (but never referred by name to the benefaction of Lane, only to that of Samuel Courtauld) Lane's thirty nine treasures as among the best of their collection of "modern Continental pictures". The Friends canvassed national opinion and passed a resolution urging the Free State to act on growing public support and press for the pictures' return. At the same time, they pressurised the County Borough Commissioners of Dublin to proceed with "the suitable and safe housing" of the part of Lane's collection currently housed in the Municipal Gallery's premises at 16 Harcourt Street; also "to form a sort of voluntary endowment for it and to keep it up to date with modern art"[12].

At the 1926 A.G.M., W.B. Yeats had urged the importance of buying "works of art before the reputations of the painters are established, or [a Gallery] will never be able to afford their price". He also lamented the "muddled" displays of the National Museum, squeezed out by the Dáil and Senate's recent occupation of part of the building hitherto theirs.[13]

In 1927, Thomas Bodkin conveyed to President Cosgrave the Friends' unanimous resolution that Lane's collection be housed in its entirety in accommodation commensurate with its quality and that of a European capital city. Support for an updated estimate for the site proposed on St. Stephen's Green by Lane, using a design by Sir Edwin Lutyens, was sought; the main point was to build a gallery "at the earliest possible moment in order to remove the strongest argument put forward in England for the retention there of the pictures"[14]. As it was now fifteen

10. A copy of this long letter is the first document filed in the records of the F.N.C.I. In her letter, Harrison states they "were to have been married" on his return from America in the summer of 1915, and that one of his principal reasons for tolerating the procrastination of the Corporation was that "Miss Harrison has put so much of her life into the scheme". Bodkin (p.73) writes, "Lane was never married; the society of women did not seem to give him any special pleasure".

11. For a full list of the pictures in question, see Bodkin, op.cit., pp. 29 - 30. They included four Corots, a Boudin, two Puvis de Chavannes, four Courbets, an Ingres, Daumier, Fromentin, Degas, two Manets, a Monet, Pissarro, Berthe Morisot, Renoir and Vuillard. For the story in detail see Bodkin, op.cit., pp. 28 - 62.

12. Letter from Sarah Purser, March 13th 1927.

13. 2nd Annual Report 1926.

14. Bodkin, op.cit., p. 64.

years since Lane's removal of his controversial paintings to London from Dublin, a huge public meeting was held in June 1928 at the Theatre Royal "to give the younger generation a full account" of the matter. Bodkin showed slides of them and summarised the case. Lady Gregory, Lane's aunt, and Major Bryan Cooper spoke and letters of support were read from Eamonn de Valera and Seán O'Casey. A few days later, a representative quota of public figures attended a public enquiry at City Hall, resulting in cautious official financial provision.

Sarah Purser then had the brainwave of housing the new gallery on the site of the 20,000 square foot garden behind Lord Charlemont's magnificent eighteenth century Dublin mansion, designed for him by Sir William Chambers; the house had recently been vacated by the Registrar-General for Ireland. In February 1929, the Government adopted her proposal "that Charlemont House together with the land behind it and as much land behind nos. 23-27 Parnell Square as might be required ... should be offered to the City Commissioners on condition that a suitable Municipal Gallery is to be erected on the site"[15]. In return for a 99 year lease and a small rent, the City undertook to spend "not less than £20,000 within four years on the conversion and extension of the building for use as a Municipal Gallery of Modern Art"[16]. The plans of the city architect, Horace O'Rourke, "for the erection of a new gallery of the most up-to-date kind" of "splendid dimensions"[17] did, unfortunately, involve "drastically" remodelling and extending Chambers' original structure and a number of the building's fine original features[18] but everyone was assured that Lane would have approved the new gallery "of lordly dimensions and scientific construction"[19]. At last a special gallery was designated to show his bequest. He had stipulated he wanted the paintings to be seen not necessarily in "a fashionable quarter" but "where there is most traffic" and they could be safe from the dangers of fire.[20] Building began immediately, with the help of a Government loan, and the new gallery was opened by President de Valera on June 19th 1933.

Sarah Purser was relentless in her work to try to increase membership, galvanise support and to secure good modern work by up-and-coming artists. This was apart from canvassing for bequests, gifts, legacies and buying pieces in danger of being lost to the nation. Members like the Belfast Municipal Gallery and the London-based Irish Literary Society publicised the aims of the Friends. The implementation of the Haverty Bequest in 1930, with its annual provision of

15. Letter February 1st 1929 from E. Blythe, Department of Finance.

16. Bodkin, op.cit., p. 66

17. Bodkin, op.cit., p. 67.

18. See Irish Georgian Society Records, Dublin 1912, Vol. IV, pp. 23 - 33.

19. Bodkin, op.cit., p. 67.

20. Ibid.

funds for purchasing pictures by Irish artists living in Ireland, led the Council to decide that the Friends should, generally speaking, allot their limited resources to follow Hugh Lane's practice "and keep our collections supplied with examples of the work of modern Continental and British painters".[21]

By December 1930, their acquisitions numbered 36, ranging from a collection of Javanese batiks, a drawing by Pietro da Cortona, a John Comerford miniature, a fourteenth century French carved ivory leaf, and early eighteenth century embroidered silk coverlet to contemporary paintings by Meninsky, Nevinson, John Nash and works by the Irish artists Albert Power, Sir William Orpen and Sarah Purser. Pieces followed by Duncan Grant and Selwyn Image and it was hoped some of the the major early 20th century modern painters (e.g. Gauguin, Degas, Van Gogh, Cézanne, Picasso, Matisse etc.) might be acquired through "wealthy donors of Irish birth at home and abroad"[22], once the quality of the new purpose-built gallery became apparent.

At its first meeting in March 1934,[23] the new gallery's Advisory Committee duly thanked the Friends for their work and valuable contributions to the collection. However, membership drives were (and still are) a prime concern. The 12th Annual Report for 1935-6 records 153 members, "a figure that is slightly above last year's membership but corresponds in no way with our population or the potential usefulness of our Society. A comparison with the National Art Collections Fund of Great Britain is hardly just to this county, but it is nevertheless worth noting that its membership has increased in thirty years from an original figure of five hundred to its present total of ten thousand, while ours in ten years has remained almost stationary. Our usefulness depends on our purchasing power and that depends on our membership. It is our money, changed into Art, that our National Collections want. To improve the position in this respect by increasing its members, we renew our annual appeal of the active co-operation of all old members in the pursuit of new ones without which the Council's propaganda falls short of its full effect.

The Council recognises that our Society offers no inducement to intending members other than an opportunity for the private discharge of a patriotic duty. This austere attitude is the probable explanation of our slow growth. It now proposes to substitute common pleasure for secret virtue and a tentative step was

21. 7th Annual Report 1931.

22. Letter April 14th 1932 from the Curator of the Municipal Gallery to Sarah Purser.

23. It is worth noting that the Society continued to operate from Dermod O'Brien's house in Fitzwilliam Square while the Chair at the A.G.M. was taken by the Lord Mayor.

taken in this direction by an At Home in January last at Mr. Egan's Gallery, in the course of the AE Memorial Exhibition.[24] Members expressed themselves pleased with the function and it is accordingly proposed to take advantage of other exhibitions for similar reunions. The Council has also in consideration the arrangement of visits by the Society to private collections in Dublin and its neighbourhood and to houses of architectural interest".[25]

As a result, an Entertainment Committee was formed, leading to a series of visits and an 80% increase in membership. The first visit was to Beaulieu, Mr. Montgomery's seventeenth century house and collection in Co. Louth; then to Castletown, Major Conolly's magnificent eighteenth century mansion in Co. Kildare and a lecture on it by Mr. William Sadleir; to the painter May Guinness in Co. Dublin and what would become an annual reception in November in the new Municipal Gallery. They also mounted a loan exhibition of contemporary painters, which included major figures like Bonnard, Chagall, De Chirico, Dufy and Derain. Sarah Purser reiterated the Society's aims and policy as far as the Gallery was concerned:

"We are anxious that this gallery be maintained as a gallery of contemporary art. Familiarity with the art of our own day in Europe is essential to the development and progress of our own. Without this constant familiarity taste is dulled and design stagnates. We are anxious that our chief Irish collection of modern art should provide this necessary contact. No state or municipal endowment is, at the moment, available in the Irish Free State to provide this vital stimulus. The absence of such provision is not creditable to our community and we cannot but regard some provision as at some time certain. But in the meantime, notwithstanding our efforts, the gaps in the gallery become every day wider and more conspicuous. We have no early examples of the first post-impressionist group … We have no examples of the living art of Central Europe or of Italy. We have no contemporary continental sculpture. Let no one charge us with lack of patriotism if we believe that our funds, as a rule, will be most usefully spent abroad. To place good examples of the best foreign artists before our students and the public is a patriotic duty, and having regard to the splendid generosity of the late Thomas Haverty the duty may be discharged without any searching of heart."

24. George 'AE' Russell, the key figure in all progressive cultural ventures in early 20th century Ireland, had been their Vice President, a foundation member and "generous supporter". Bodkin filled the vacancy caused by his death.

25. 12th Annual Report 1936. This policy is still in operation.

They proposed to pursue an "attempt to forecast taste upon whose success only posterity can securely judge" and felt "a duty to give representation to movements in art with which we may not all, or always be in complete sympathy but which at any rate has powerfully affected its development. These are risks we may not shirk".[26] Their recent bequests included works by Jean Lurçat, Henry Tonks and Stanley Spencer.

In 1937 the Organising Committee's events included a lecture on 'Italian Schools of Painting in the National Gallery' by its director, Dr. George Furlong, and visits to the tapestries and paintings at Mrs. Shelswell-White's Bantry House in Co. Cork, to Derrynane, home of Daniel O'Connell and his descendants, to the Gaisford St. Lawrences' historic Howth Castle., to the Provost's House within Trinity College and to Dr. and Mrs. Cremin's collection in Richard Cassell's masterpiece, 122 St. Stephen's Green. The President attended the gala annual reception, which revived the civic tradition of inviting the presence of the Dublin Fire Brigade. Acquisitions included a rare fragment of twelfth/thirteenth century woven patterned Lucchese silk and a sixteenth century Persian brocade, both for the National Museum. At the January 1938 A.G.M., Sarah Purser, by now aged 90, announced her retirement after 13 years as the Honorary Secretary of the Friends, although she continued as one of the four Vice-Presidents. A dinner was given at the Shelbourne Hotel in her honour, with a menu cover designed by Jack Yeats.

In 1938 members of the Society were received by Viscount Powerscourt at Powerscourt, by Thomas Bodkin's brother, the Rev. Matthew Bodkin S.J. at Belvedere House, at Drumcondra House built for the Coghills in 1720, at the restored Casino by Sir William Chambers at Marino, led by Harold Leask, Inspector of National Monuments, at the Norman Pale castles of Killeen and Dunsany. They also attended a lecture at the Royal College of Surgeons on 'The French Mind in Art' by a conservateur from the Louvre. At the annual reception, attended by the Taoiseach, the Society's president, the Earl of Granard, received over 300 members, along with Dermod O'Brien and Sir John Leslie, Vice Presidents, and the painter, Eva Hamilton, representing the Council. Because Dublin's Gallery of Modern Art still had "no public endowment, national or municipal, for the purchase of pictures", resulting in its being "precariously dependent upon casual gifts" for its " modern character", the Society had decided

to spend a "substantial portion of its funds" on paintings by two major European artists, Picasso and Utrillo. They also bought for the National Museum a set of Uileann Pipes by the Dunhallow piper, Donnchadh O'Laoghaire and, mystifyingly, 16 colour reproductions of well-known contemporary European painters. A Nathaniel Hone self-portrait and Nicholas Crowley portrait were among several fine Irish works presented through the Society in what was their busiest year yet. Partly because of the War, 1940 saw a decline in membership and social activities, although a Bonnard oil, *Boulevard Clichy, Paris* (1895) and a Matisse lithograph, *Danseuse refletée dans la glace,* were purchased, a lecture on contemporary French painting was organised and visits were made to Slane Castle and Piltown.

In 1942, Dermod O'Brien assumed the Presidency of the Friends from the Earl of Granard, who had held the office since the Society's inception; this office O'Brien, who was still also the President of the R.H.A., held until 1945, when he was succeeded by the Earl of Rosse, newly elected as a Vice-President. It is interesting to note that on the Council there were three other painters: May Guinness, Eva Hamilton and Mainie Jellett, as well as eminent art historians: C.P. Curran, George Furlong, Françoise Henry, Ada Leask and Dudley Westropp. Despite the War and a drop in membership and activities, Sir Kenneth Clark, then Director of the London National Gallery, lectured "brilliantly" on 'The Still Life' in the Abbey Theatre; C.P. Curran, the distinguished architectural historian of Dublin's eighteenth century plasterwork, a founder Council member and later Vice-President of the Friends, who in 1940 had presented nearly 200 designs by the Dublin master stuccadore, Michael Stapleton, gave detailed talks to members during visits to eighteenth century Dublin townhouses; and the Society organised its first exhibition, a centenary show of the early nineteenth century Irish romantic landscape painter, James Arthur O'Connor, at the Municipal Gallery. New members included the painter Lady Glenavy, the historian Constantia Maxwell and the art historian Thomas MacGreevy. That year, the Municipal Gallery's Art Advisory Committee was too scandalised to accept an offer of the loan of Georges Rouault's powerful *Le Christ et le Soldat* ("I go into a gallery for the relaxation and sense of peace and enjoyment one gets from being among things of beauty", wrote one outraged member, suspending his subscription. "Pictures like this induce only a feeling of depression, disgust and anger so far as I personally am concerned"). Ironically, the President of Maynooth College accepted its loan "with the greatest pleasure" and promised to ensure its

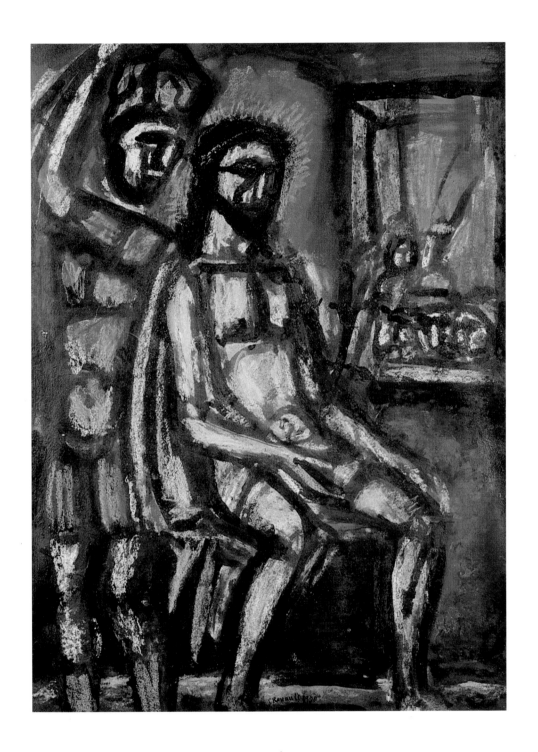

Georges Rouault (1871-1958) | CHRIST AND THE SOLDIER (1930)

Hugh Lane Municipal Gallery of Modern Art, Dublin

accessibility to students, visitors and "even Bishops!"[27]. The publicity which attended the Gallery's scandalous rejection of the picture and its subsequent exhibition in the Royal College of Surgeons, drew the open support of existing members like Evie Hone and Mainie Jellett as well as new members. The latter gave a thought-provoking lecture on 'Painting and Understanding', as a sequel to one by the distinguished English art critic Eric Newton's lecture on 'The Meaning of Modern Art'.

The 1944 A.G.M. was overshadowed by the deaths of key members of the Society: Sarah Purser, Sir John Leslie, Mainie Jellett and Mrs. G.B. Shaw. A Berthe Morisot watercolour, a Vlaminck cubist composition, *Opium,* and a Mary Swanzy portrait were among pictures from Sarah Purser's collection presented through the Society from her estate. Although these should be seen as major investments, ready funds were still short, particularly as the last two years had seen a substantial rise in European market prices. It seemed impossible to secure more than 300 members; meanwhile "the work of the great European Masters of the last 60 years" was "conspicuously unrepresented"[28]. In an attempt to represent the "developments that have taken place in the various schools of painting on the Continent…from…the French Impressionists to our own day," the Society planned to hold a Loan Exhibition of over 90 major paintings and drawings that summer in the National College of Art and Design, this, at a time of "marked increase of interest in painting in this country". Its success resulted in the subsequent acquisition, in 1948, of a good Dunoyer de Segonzac watercolour, *S. Tropez,* for Charlemont House, skillfully engineered by the Society's Honorary Secretary, R.R. Figgis. Among the 32 new members for that year were Louis le Brocquy and James White.

It was still a matter of grave concern to the Friends that "Of our metropolitan collections, the Municipal Gallery alone remains totally inadequate in fulfiling the function for which it was founded. In attempting to deal with this lamentable state of affairs this Society is up against a depressing problem. The few hundreds annually at its disposal are wholly insufficient of any scheme of systematic purchasing of contemporary work, much less for any determined effort to secure examples of the art of those earlier painters who though still classed as "moderns" have long since, in monetary value and international prestige, joined the ranks of the Old Masters.

27. Letter dated November 21st 1942.

28. 20th Annual Report 1944.

We all look forward to an expanding tourist traffic and it is of paramount importance that our National Collections should be a source not only of inspiration to ourselves, but of interest to others … If public funds were available for this purpose, we should feel its achievement to be still nearer realisation."[29]

The Honorary Secretaries recorded a Mainie Jellett bequest to the National Gallery, as well as a collection of china to the National Museum, but lectures by Bodkin (in his capacity as Director of the Barber Institute of Fine Arts in Birmingham) and Sir John Rothenstein (Director of the Tate Gallery in London) had had to be postponed. The 22nd A.G.M. in 1946 marked the death after illness of the Society's firm supporter and President, Dermod O'Brien, and the first year of Lord Rosse's long and active Presidency and Chairmanship of the Friends. It also saw the post-war resumption of the Annual Reception, the delivery of Rothenstein's lecture on 'Recent Developments in English Painting' and plans for sponsoring and organising two exhibitions at the Municipal Gallery the following year; one to show *Modern Czechoslovakian Painting and Sculpture,* the next the development of *Twentieth Century French Painting.* C.P. Curran's extensive knowledge of eighteenth century Dublin plasterwork continued to be appreciated on visits to the Rotunda Hospital and to St. Saviour's Orphanage in Dominick Street, while the notable collection of Edward McGuire, Council member, was the focus of another visit. Victor Waddington was among new members at this time.

As the 101 acquisitions listed in the 24th Annual Report of 1948 demonstrate, the Friends were not exclusively concerned with trying to establish the capital city's Gallery of Modern Art, partly because of the successful activities of artists (and Council members of the Friends) like Norah McGuinness, a founder member of the now thriving Living Art exhibition (founded 1943)[30]. That year they acquired a superb eighteenth century Irish carved wood gilt couch that had belonged to Lord Charlemont, and William Turner de Lond's painting of *The Ceremonial Entry of George IV into Dublin* (1821) for the National Gallery. Through their activities, public galleries outside Dublin and Belfast - Cork, Galway, Clonmel, Kilkenny, Maynooth, Limerick - were included in bequests, as well as the National Museum, the Royal Hibernian Academy, the Royal Society of Antiquaries of Ireland and the National Library, all based in Dublin. Similarly, for receptions and lectures (e.g. by the Director of the Glasgow Art Gallery and Museums on 'Contemporary Art Criticism') they took advantage of a variety of public institutions in the city, such as Newman House, the Provost's House, the

29. 21st Annual Report 1945.

30. She and Terence de Vere White both became Council members that year. Norah McGuinness became the dynamic Chairwoman of the I.E.L.A. (Irish Exhibition of Living Art) in 1944. For its origins, see Brian Kennedy, 'Women artists and the Modern Movement, 1943 - 9' and Brian Fallon, 'Irish women artists in the nineteen-fifties', in *Irish Women Artists,* op.cit., pp. 41 - 5 and pp. 46 - 7.

Royal College of Surgeons as venues. These were usually attended by the President or the Taoiseach. In emulation of Sir Hugh Lane's Vuillard in his still not permanently secured collection of 39 "modern Continental" pictures, they acquired a further early gouache by the French Post-Impressionist painter for the National Gallery, as well as *Ferme* by Charles Daubigny. Other acquisitions included bequests by Lily Yeats of her father's work, a School of Bassano *Procession to Calvary* for the National Gallery and, on the advice of Evie Hone, a still life by Francisco Bores and a landscape by Andre Lhote[31]. Once more, in 1949, the Council felt the need to reiterate its policy as regards purchasing modern works of art, to which it was not solely bound:

"A visit to almost any modern gallery in any capital city of the world, outside Dublin, is sufficient to demonstrate that the modern idiom in its various manifestations has long been generally accepted. Most modern galleries tend to start where our Municipal Gallery leaves off. In consequence, the few, the very few, pictures that our Municipal collection possesses that are really representative of contemporary painting on an international plane, look out of place because they are seen outside their context. On the other hand, to any informed visitor to Dublin, the vast majority of the pictures in Dublin's modern gallery must inevitably appear to be an anachronism. This Society, with its small membership and modest income, has done its best to repair the deficiency. Picasso is represented by a small oil-painting, but by nothing that would give the enquiring visitor any conception of the power and versatility of this painter's work. Bonnard, one of the most honoured names in twentieth century painting, and fast qualifying to become an old master, is well represented by an important early oil painting. Lurçat, Utrillo, Segonzac are each represented by one picture. Rouault, one of the great religious painters of all time, remains unrepresented through no fault of this Society.

"Your Council feels that the time has come to call for more co-ordination in the administration of our public galleries, and for some scheme to be devised whereby Charlemont House may be enabled to justify the retention of the word" modern" in its official title. Further, your Council respectfully suggests that the time has come when good photographs and reproductions of all that is outstanding in our various public collections should be made available to our own public and to visitors to our capital city".[32]

31. Both the latter had featured in the 1950 I.E.L.A.

32. 25th Annual Report 1949.

The problem was, as always, rising market prices. The tireless honorary secretary, R.R. Figgis, enlisted the advice of Basil Ivan Rákóczi, a founder member of the White Stag war-time group of Dublin painters[33] in trying to secure a Matisse through his friend the Abbé Morel, who gave "a brilliant and stimulating paper on 'Le Tragique et l'Art de Notre Temps' at the end of the year; but this proved beyond their means.

The setting up of An Chomhairle Ealaíon, the Arts Council, in 1951, four of whose founder board members were also F.N.C.I. Council members, reflected the Society's fundamental role in the nation's cultural concerns ("The visitor to Charlemont House cannot fail to observe that almost everything of significance on the walls of that gallery painted within the last thirty years has been presented by this Society"[34]). When an exhibition of contemporary Swedish art came to Dublin, it was the Friends who organised a reception at Charlemont House. They also achieved a successful settlement of the late Jerome Connor's unfinished and long overdue Lusitania Memorial for Cobh. 1954–5 was an outstanding season: the President supported the Society by agreeing to become its Patron, and far more new members and new acquisitions and bequests were secured than ever before in one year. This was mainly due to James White, newly elected to the Council (on which he still serves as a consummately experienced member) and in charge of an extensive countrywide membership appeal; and partly to the most exciting new acquisition, a Henry Moore bronze *Reclining Figure.* This had been exhibited in Kilkenny and at the Living Art Exhibition, but rejected (as the Rouault had been[35]) by the Municipal Gallery's Art Advisory Committee. While Council member Erskine Childers, then Minister for Posts and Telegraphs, wholeheartedly supported the "artistic prescience" and "independence of judgment…impossible under any system of bureaucratic purchase" shown by the Friends, Council member Lady Dunalley, in her distaste for Moore's sculpture, declared "that she considered modern Art decadent". P.J. Little, Director of the Arts Council, affirmed "that the Society, labouring against a tide of apathy and neglect, had accepted the onerous work of creating a public patronage of art" and must try to persuade any "people of real knowledge and taste scattered throughout the country" to lend their support.[36]

James White's success in recruiting new members was such that he assumed Bobs Figgis's Honorary Secretaryship in 1956, while joining him on the Executive

33. See Kennedy, op.cit., pp. 40 - 1.

34. 28th Annual Report 1951 - 2.

35. Council wrote a carefully judged letter asking the committee to reconsider its decision, but the matter was unresolved for some years.

36. A.G.M. minutes.

AN INDIAN LADY, PERHAPS JEMDANEE (1787) | Thomas Hickey (1741-1824)

National Gallery of Ireland, Dublin

Committee along with Norah McGuinness, Brigid Ganly, C.P. Curran, Terence de Vere White, Sir Alfred Beit, Sir Basil Goulding, Françoise Henry and Thomas MacGreevy (by now Director of the National Gallery of Ireland). That year the Council was expanded to represent all parts of the country (Henry McIlhenny, and later Derek Hill, in Donegal, Sir Chester Beatty in Dublin, Lord Killanin in Galway, Dennis Gwynn in Cork etc.); Erskine Childers and Cearbhall O Dalaigh were among those on the existing Council. This was responsible with Bord Fáilte for mounting an exhibition of Japanese prints from the collection of Sir Chester Beatty, a new Vice President of the Friends. It also arranged a lecturer from America, a visit to the Beit Collection at Russborough and a series of exceptional acquisitions. These included important work by Sir Jacob Epstein (two sculptures), George Chinnery, Daniel Maclise, John Van Nost, Augustus St. Gaudens, James Barry; they were also instrumental in securing Augustus John's portrait of W.B. Yeats for the Abbey Theatre. Other activities included their successful campaign to remove government tax on artists' work entering the country (at the instigation of Seán Keating P.R.H.A.), a handicap on which the current law has sadly regressed. The 1957/8 year saw the election of Anne Crookshank, then Keeper of Art in Belfast, and the renowned collector John Hunt to the Council, while the executive committee investigated modern French paintings to fulfil Evie Hone's substantial bequest of £500 for such. Over 30 works by her were bequeathed or acquired, as well as a couple by Jack Yeats, a Nano Reid and important paintings by Thomas Hickey, James Barry and Hugh Douglas Hamilton (the latter three for the National Gallery). Visits, a lecture, a festive opening of *Paintings from Irish Collections* (with Bord Fáilte) and a Cork Chapter drew new members.

Speculation over the Lane pictures was revived in 1959 when Sir John Rothenstein gave a lecture on 'British painting since the War'. Soon after, an official compromise was reached through the offices of Thomas Bodkin and Lords Moyne and Longford, resulting in the pictures' alternation between their two claimants.

By 1960 two problems, which are still major concerns of the Friends, were voiced: that no restrictions exist to prevent works of art streaming out of Ireland, usually for profit abroad; and that the steep rise in art prices "and enormous interest in all works of art of value in the international market" were proving

preclusive to purchase even at a comparatively early stage in an artist's career. Consequently, "The policy of buying works by promising young artists is the only possible one under the circumstances ... Your committee is not unaware of its responsibilities, no matter how bitterly it regrets the opportunities it has to turn down for lack of funds ... Not one single penny is spent in this country outside this Society to acquire works by living non-Irish artists. The responsibility is totally ours...and our resources are our members ..."[37]. Thus, two distinguished collectors, Lady Dunsany and Lady Mayer were co-opted on to the Council and gifts did continue to be presented, bringing the total number of accessions to 195. At the end of the year, two new categories of membership were introduced: life (15 guineas) and junior (5/- per annum) for under 18's and those attending universities or art colleges.

James White's appointment as Curator of the Municipal Gallery in 1960 meant that first Anne King-Harman and then John Turpin shared his duties as Honorary Secretary (since, apart from the extra work of this new commitment, he could not write letters to and from himself as Secretary of the Friends and as Curator of the Gallery). His double position was an enormous boost to both Gallery and Society. In 1962 the Friends' contribution to Anne Crookshank's enlightened purchase of works by Ceri Richards, William Scott, Roger Hilton and Terry Frost for the Belfast Art Gallery and to a collection of Jack Yeats paintings for the Sligo Museum was warmly supported by him. At the behest of Sir Alfred Beit, Sir Kenneth Clark waived his usual fee for an enthusiastically attended lecture on Rembrandt's paintings. In 1963, James White, as Honorary Secretary, drew welcoming attention to the newly formed Contemporary Irish Art Society, whose aim was to supplement, not compete with the activities of the Friends, since the latter had decided not to acquire works by living Irish artists. That year the Society received Thomas Bodkin's bequest of 38 works of art for distribution and enjoyed a lecture on the Icarus theme by Michael Ayrton (in 1976 it would acquire a bronze *Minotaur* by him). 1964 saw several new members added to Council, some of whom still serve on it, the longest serving member now being James White. He was instrumental in the Friends' next major undertaking: an exhibition in August-September 1964 in the Municipal Gallery, and then in the Ulster Museum, of the works acquired by the Society since its foundation. A small but steady flow of acquisitions, particularly through Sir Alec Martin, a long-term supporter, and some by the Hungarian artist of Irish blood, Ferenc

37. 36th Annual report
1959 - 60.

Martyn, continued along with lectures and visits. Still, "not one single penny had ever been spent by the Corporation on purchasing works whilst the Friends had kept the Gallery alive by putting into it works worth £200,000. Dublin is the only municipality in the world which makes no contribution to purchases of works of art".[38]

The Society also undertook to erect house plaques to Sir Hugh Lane and Walter Osborne. Sadly, they did not make any purchases when the first 'ROSC' exhibition was held in Dublin in 1967, partly because their resources had been stretched by the purchase of a Guttuso painting, *Red Roofs,* in 1965. This opportunity was consistently missed every four or so years during successive ROSCs when contemporary avant-garde art works were in Dublin and physically, if not always financially, accessible. Proposals to buy Bill Woodrow's superb *Elephant* at the 1984 penultimate ROSC at the Guinness Hop Store came to nothing, although the Council bought a fine Albert Irvin painting, *Caledonia,* for Kilkenny as a direct result of his inclusion in the same show. Purchases were also made at subsequent major David Nash and Clifford Rainey exhibitions in the 1980's, and Dublin Corporation did buy Christo's *Wrapped Walkways,* purposely designed (but not, eventually, executed) for Dublin's St. Stephen's Green during the 1977 ROSC. 1968 saw the acquisition of an Elizabeth Frink bronze *Cock* and Ivon Hitchens' *Ringed Lily,* further visits, a goodwill address from the now well-subsidised North of Ireland, represented by Capt. Peter Montgomery (who urged support for the new galleries in Fermanagh and Derry). A profit of £800 was made on the infamous Midsummer Ball at Castletown House, held in collaboration with the Irish Georgian Society, at which Mícheál MacLiammoir gave a dramatic performance. By 1969, James White's incipient appointment as Director of the National Gallery, in succession to Thomas MacGreevy, led to his handing over the Hon. Secretaryship after nearly twenty years to John Turpin and John Gilmartin, although he still served actively on the Council.

1970 was a historic year in that Dublin Corporation contributed £300 to the sum of £2,700 for a Josef Albers painting, *Aglow,* bought by the Society from David Hendricks - "This was the first occasion on which the Civic Authorities of Dublin contributed towards the purchase of a work of Art for the Municipal Gallery"[39]. The Friends also contributed to the purchase of a fine piece of eighteenth century Dublin silver for the Ulster Museum, bought three

38. Dr. F.H. Boland in Minutes of 1966 A.G.M.

39. Secretary's Report 1970.

contemporary French stained glass panels from Evie Hone's collection and turned up in record numbers to a series of visits, including a now legendary one to the Provost's House conducted by Anne Crookshank and Professor Otway-Ruthven. They also voiced deep general concern over the condition and role of the National Museum, leading to the formation of a Museum Committee, and the preparation of a detailed Report.[40] That year, Charles Haughey, T.D., Minister for Finance, proposed the adoption of the Annual Reports. 1971 was marked by a profitable fund-raising Antiques Quiz at the the King's Inns, chaired by Peter Wilson of Sotheby's, the purchase of a Leopoldo Novoa abstract, *Grand Gris á Cinq Elements,* and visits to the various ROSC exhibits, particularly Hilary Pyle's *Irish Art 1900 - 1950* in Cork. In 1972, when Peter Harbison assumed the duties of Hon. Sec., the total lack of requests for aid made the Friends determined to combat and investigate a general ignorance of their possible aid throughout the country. At the 1973 A.G.M., the eccentric editor of *The Arts in Ireland* magazine, Charles Merrill, called for the appointment of a Minister of Cultural Activities.

The F.N.C.I. celebrated their 50th anniversary in 1974 with exhibitions of selected works presented by the Friends to the Municipal Gallery and other galleries by Sarah Purser, the Society's founder. These were organised by the Curator, Ethna Waldron and Dr. Elizabeth Fitzpatrick (née Purser), the Hon. Treasurer.[41] There were also visits to Emo Park and Glin Castle and a number of varied but important acquisitions and distributions of bequests. The Friends were rewarded with exemption from income tax (being a charity) and a moderately optimistic response to their proposals on Capital Gains and Wealth Tax, particularly where private individuals were concerned. James White, by now a Vice-President of the Friends, gave a lecture in 1975 commemorating the centenary of Sir Hugh Lane and welcomed the advent of a new national institution in Dublin, The National Trust Irish Architectural Archive. Dr. Edward McParland addressed the 1976 A.G.M. on the role of the Archive, the same year in which Malahide Castle and some of its contents were secured for the nation, and Lord Norwich lectured in the National Gallery. In 1977 Ciarán MacGonigal, who had been chairing a sub-committee drawing up a detailed report on the future rôle of the Friends, took over as Honorary Secretary. His outgoing Annual Report of 1979 summed up the position of the Society now that the Irish Museums Trust, Friends of Modern Dublin and the Contemporary Irish Art Society had been established, the newly renamed Hugh Lane Municipal Gallery

40. "The sad position of the National Museum still after 50 years of self-government in the stranglehold of the Department of Education, has to be continually ventilated..Even if a Minister of Culture is not going to be established, at best the Museum could be restructured ... "(William Dillon, '50 years of the Friends', *Irish Times,* March 28th 1973).

41. The late Dr. Fitzpatrick was notably active at this time in her countrywide survey of galleries, museums and public organisations.

of Modern Art could avail of Dublin Corporation's annual purchasing fund of £30,000, and taxation problems to the detriment of art works were being addressed. Many other issues discussed over the years are still as pertinent as ever: e.g. the destruction of historic public monuments and architecture in Dublin; the legislation for, classification and preservation of historic monuments and their contents; the documentation, legislation and state aid for the continuing export of works of art of national importance; the vital need to set up a Georgian town house as a museum, like those in Charlotte Square in Edinburgh and The Royal Crescent in Bath; the tax on artists' materials and any artwork painted less than 100 years ago (now altered but still unsatisfactory).[42] The much discussed extension to the National Gallery of Ireland has now been successfully completed, while a subsequent controversial scheme has been the subject of a planning appeal; the Royal Hospital, Kilmainham has been magnificently restored and adapted as the thriving and well-funded Irish Museum of Modern Art, while the Hugh Lane Gallery has found vigourous public and private sponsorship for a variety of well-presented exhibitions and new acquisitions under its lively new Director, Barbara Dawson. The Gallery is still under the aegis of Dublin Corporation. Furthermore, the Douglas Hyde Gallery in Trinity College, Dublin, with substantial funding from the Arts Council and other sponsorship, has mounted a series of pioneering exhibitions which often complement themes and artists featured at IMMA. The National Museum of Ireland has extended its premises to Collins Barracks, although does not yet display more than a selection of its holdings, which still lack a comprehensive catalogue. The Irish Architectural Archive has moved to larger premises in Merrion Square, and continues work on its database of architects who have worked in Ireland.

Since Lord Rosse's death, James White, Lady Dunsany, Judge Brian Walsh, John Ross, Harold Clarke, Alderman Carmencita Hederman and Brian O'Connor have each presided over and chaired the the proceedings of the Society. In 1984, its 60th anniversary was celebrated by the erection of a plaque denoting the original Municipal Gallery outside the Earl of Clonmel's fine Georgian house in Harcourt Street, the commissioning of an intricately detailed drawing of Clonmel House for graphic reproduction as a logo by Michael Craig, the well-known stamp designer, and a reprint of the catalogue of the Gallery's original collection in 1908. This was launched at a reception at Charlemont House. Events culminated in the presentation of a major painting by the Australian-Irish artist,

42. A covenant scheme for would-be purchasers of art works giving adequate tax incentive and provision was first suggested by James White at the 1974 A.G.M.

Sidney Nolan, *Ned Kelly by the River,* at an A.G. M. addressed by James White at the Royal Irish Academy.

The purchase of works of all periods continues to be made or assisted, so that 46 venues all over Ireland have pieces on display which have been acquired through the Friends. These include a high proportion of paintings, some of considerable international importance, others important components in a national context; there are drawings, sculpture, prints, textiles, silver, objets de vertu, china, carvings, furniture, stained glass, photographs, manuscripts, book illustrations, jewellery. A selection of these forms this 75th anniversary exhibition display drawn from the first full catalogue of work which Aidan O'Flanagan, current Hon. Treasurer of the Friends, has compiled. At the same time, he is building up a slide library of these extensive holdings; these slides have already provided the visual material for lectures given on the history of the Friends. He has also collated the archives of the Society, and transferred them from the Municipal Gallery to the Irish Architectural Archive, where they can be easily consulted, while the Annual Reports delivered at 73 successive A.G.M.s are now deposited in the National Library of Ireland. Although some important guest lectures have been given, notably on the occasions of annual general meetings, these became an annual fixture from 1998, due to the generosity of a UK bequest. A quarterly Newsletter inaugurated in 1997 suggests that this voluntary organization should continue, after 75 active years, to play a role in the dissemination of art in Ireland.

Nicola Gordon Bowe was Honorary Secretary of the FNCI 1983 – 1985, and a member of the Executive, Purchasing Committee and Council 1980 – 1990

Sir Sidney Robert Nolan (1917–1992) | NED KELLY AT THE RIVER (1964)

Hugh Lane Municipal Gallery of Modern Art, Dublin

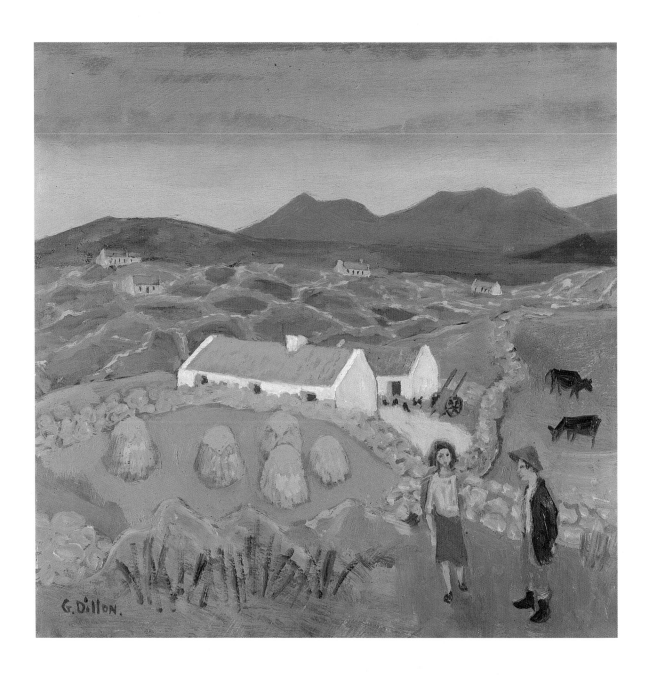

FIGURES IN A CONNEMARA LANDSCAPE | Gerard Dillon (1916–1971)

Butler Gallery, Kilkenny

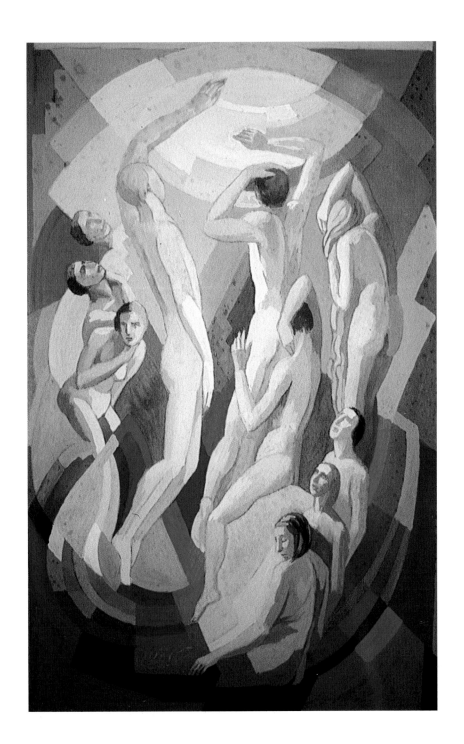

Mainie Jellett (1897–1944) | FIGURES (1946)

Butler Gallery, Kilkenny

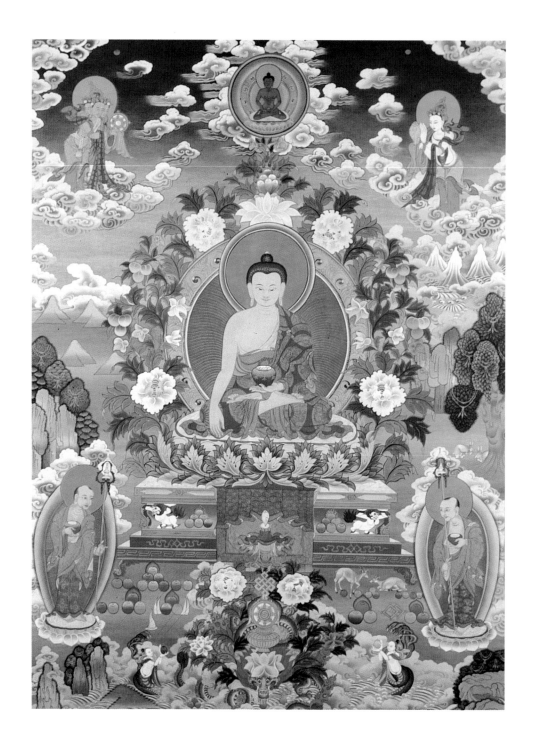

SHAKYAMUNI BUDDHA | Romio Shrestha (b.1961)

Chester Beatty Library, Dublin

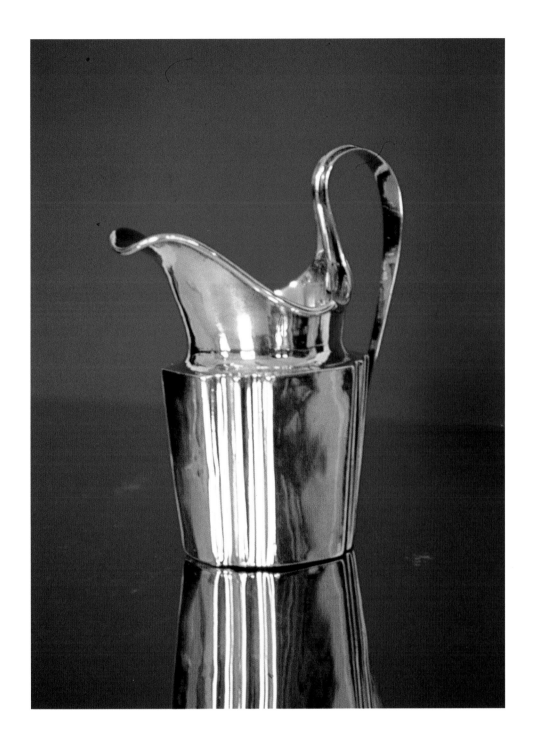

William Heyland (c.1795) | GEORGE III OBLONG MILK JUG

Cork Public Museum

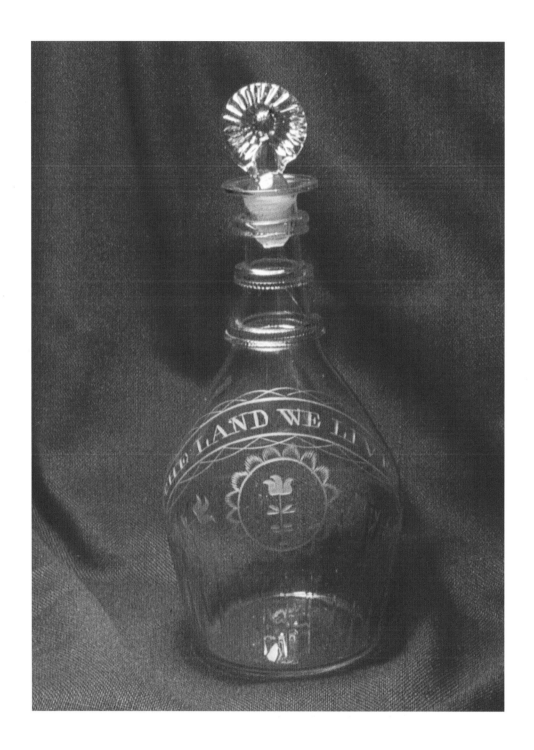

"UNION" DECANTER, EARLY 19C | Cork Glass Company

Cork Public Museum

Hallmark Obscured | TOBACCO BOX, c.1835

Cork Public Museum

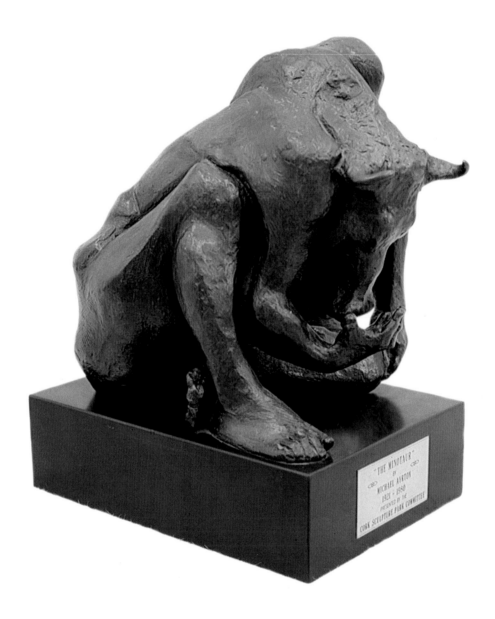

THE MINOTAUR | Michael Ayrton (1921-1980)

Crawford Municipal Art Gallery, Cork

Peter Murray

THE CRAWFORD MUNICIPAL ART GALLERY IN CORK *can trace its foundation to the year 1819, when* A COLLECTION OF CASTS FROM SCULPTURES IN THE VATICAN MUSEUM *was presented to* THE CORK SOCIETY OF ARTS.

This cast collection formed the nucleus of the School of Art founded that same year. By 1884, the school had become the Crawford School of Art, and a series of magnificent painting and sculpture exhibition galleries was added in that year to the old Custom House building that had housed the school and its art collection since 1830. In 1979, the Crawford School of Art moved to a different building, and the old teaching studios became new galleries for exhibiting the growing collection of the Crawford Municipal Art Gallery. The sculpture collection at the Crawford now includes works by Irish sculptors Hogan, Heffernan, Willis and Murphy, as well as important works by eighteenth-century English sculptors Joseph Wilton and John Bacon. Among the paintings are works by James Barry, Daniel Maclise, Jack B. Yeats and Seán Keating. There is a significant and growing collection of works by contemporary Irish artists.

The support shown to the Crawford Gallery by the Friends of the National Collections of Ireland extends back almost fifty years. In 1955, the Friends presented to the Crawford a number of works by Daniel Maclise, including the important painting *The Falconer.* Maclise was one of a number of talented artists, Samuel Forde and John Hogan among them, who enrolled at the newly established Cork School of Art in 1819. While still a teenager, Maclise established a prosperous portrait practice in Cork, helping to support his widowed mother and family. A quick sketch he made of Sir Walter Scott when the famous novelist

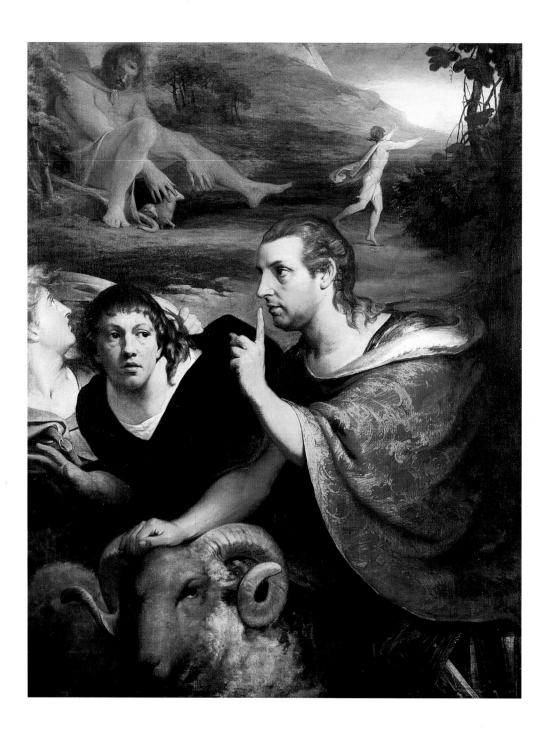

PORTRAITS OF BARRY & BURKE IN THE
CHARACTERS OF ULYSSES AND HIS COMPANION
FLEEING FROM THE CAVE OF POLYPHEMUS

James Barry (1741–1806)

Crawford Municipal Art Gallery, Cork

visited Cork in 1826 helped confirm his fame and the following year he moved to London, becoming one of the most outstanding students at the Royal Academy Schools. In 1830, he began a series of portraits of literary and political figures which were engraved for *Fraser's Magazine,* and a number of these pencil sketches, including one of Lady Blessington, were included in the gift to the Crawford. Maclise's ambition to become a great history painter was possibly inspired by the example of Cork artist James Barry and resulted eventually in his being awarded the commission to decorate the newly-built Houses of Parliament in London with a series of giant frescos celebrating British victories on the battlefield.

The subject of the *The Falconer* may well have been inspired by a fourteenth-century Florentine folk tale, *Federigo's Falcon.* Maclise, who always paid meticulous attention to historical authenticity in the costumes and settings in his paintings, depicts the falconer and his lover in Renaissance costume. The figures are in an outdoor setting but as with most of Maclise's paintings this has the feel of a theatrical backdrop. The relationship between the two protagonists, full of repressed passion and sensuality, is very typical of the Victorian era, and it is no surprise to learn that Maclise was a great friend of Charles Dickens and William Makepeace Thackeray, two of the greatest novelists of that era.

The following year, in 1956, the Friends of the National Collections presented to the Crawford Gallery what is perhaps the most important single work in the collection, *Portraits of Barry and Burke in the Characters of Ulysses and his Companion fleeing from the Cave of Polyphemus.* This painting, an oil on canvas, dates from around 1776, and is a complex allegorical work that combines classical mythology, the politics of Barry's day, and a strong autobiographical subtext.

Barry was born in Water Lane, Cork on 11 October 1741. He first studied painting under local artist John Butts and in 1763 went to Dublin, studying with Jacob Ennis at the Drawing School of the Dublin Society. The politician Edmund Burke took an interest in his career and in 1764 provided him with an introduction to Joshua Reynolds, President of the Royal Academy in London. Encouraged by Reynolds and financed by Burke, he visited the Continent in 1765, remaining there until 1771. Barry had high ambitions as an artist, aspiring to become a history painter in the grand classical tradition. The strong moral and social content in his paintings shows him to be an early Neo-Classicist. Although he was to achieve considerable fame and reputation as a painter in London, his career was thwarted by his political beliefs, an argumentative nature and financial misfortune.

After coming back to London in 1771, he turned to printmaking and illustrating in order to support himself. He also regularly exhibited works at the Royal Academy, becoming a member in 1773 and Professor of Painting in 1782. His famous cycle of history paintings at the Society of Arts was unveiled in 1783 to great acclaim, but Barry was paid a mere £503 for his work. His outspoken criticisms directed against Sir Joshua Reynolds, the Royal Academy, the Government and society in general eventually led to his expulsion from the Academy. Between 1783 and his death, he completed only four major history paintings, and none sold during his lifetime. He fell ill in 1803 and Sir Robert Peel and the Society of Artists secured a pension for him in 1805. He died the following year.

In 1775 James Barry published a book entitled *An Inquiry into the Real and Imaginary Obstructions to the Acquisition of the Arts in England,* in which he attempted to promote the art of history painting in Britain. The following year he painted *Ulysses and Polyphemus.* On one level this is a double portrait of Barry and the statesman Edmund Burke. On another level it shows the Classical hero Ulysses and a companion who disguised themselves as sheep in order to escape from the cave of the blind giant Polyphemus. On an autobiographical level, it shows the politician Burke cautioning the impetuous artist whose outspoken comments on the British Government's policies, particularly in relation to the American War of Independence, were to hasten his eventual expulsion from the Royal Academy.

The support of the Friends towards the Crawford continued over the years. Significant works of art presented include two paintings by William Mulready: *Farm Buildings with Pond and Ducks* and *Nude Study;* William Otway McConnell's painting *The Throne of the Gods and this Strange World;* drawings by Thomas Rowlandson, Mervyn Peake and Augustus John; Henry Marriott Paget's *Portrait of John O'Leary;* a country scene attributed to Jan Breughel and a portrait by George Sharp. The Friends have also assisted in the purchase of James Brenan's *Patchwork,* a fine genre painting by an artist who for thirty years was the headmaster of the Crawford School of Art, as well as important works by Cork artists George Mounsey Wheatley Atkinson and Daniel MacDonald. The connection between Cork and Sir Hugh Lane, who was born in that county in 1875, was commemorated in the presentation in 1961 of Gerald Festus Kelly's portrait of that great patron of the arts. Sir Alec Martin, who had helped the Crawford acquire this portrait from a nephew of Ruth Shine (Lane's sister), also

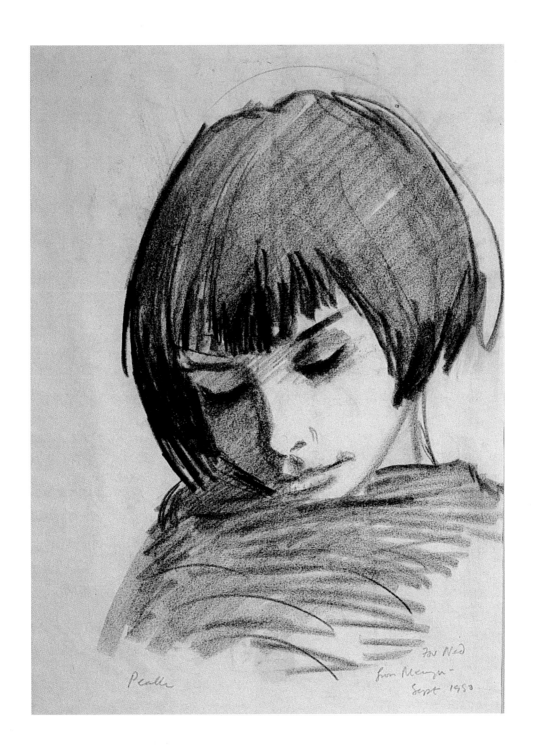

Mervyn Peake (1911–1968) | HEAD OF A GIRL

Crawford Municipal Art Gallery, Cork

RETURNING FROM THE BATHE MID-DAY, 1948 | Jack B. Yeats (1871–1957)

Crawford Municipal Art Gallery, Cork

at this time presented through the Friends an impressive French Empire chair. The gallery's record of this gift documents it as Lane's 'favourite desk-chair', from his house at Cheyne Walk in Chelsea.

In more recent years, the Friends presented Paul Signac's fine watercolour *Concarneau,* an important addition to the Crawford's holdings by French artists of the 20th century, Michael Ayrton's bronze sculpture *The Minotaur* and an abstract watercolour by Hungarian artist Ferenc Martyn.

Jack B. Yeats' *Returning from the Bathe, Mid-Day,* painted in 1948, is again one of the most important works in the Crawford collection and would not have come to Cork were it not for the generous assistance of the Friends. A late work by Yeats, it shows the artist at his best, when the forms of his figures and landscapes have been practically dissolved in a sea of colour yet are still clearly discernible. In this painting, figures return from the beach after a morning bathe – a memory almost certainly of the idyllic childhood summers spent by the artist in Sligo with his Pollexfen relations. Thomas McGreevy wrote of Yeats paintings of this period "It is this capacity of Jack Yeats to get a quiveringly intensive vitality of effect by the most economic means, by a few strokes of the brush or the palette knife, which gives artistic justification to these marvellous colour compositions of his later years". The painting is full of sunlight and optimism and a sense of that spirituality and other-worldly feeling which imbues most of the late paintings of Yeats.

Apart from Yeats, the Friends have assisted in building up the Irish twentieth century art holdings of the Crawford, presenting an important abstract oil painting by Mainie Jellett, two landscapes by J.M. Kavanagh, and watercolours and gouaches by Evie Hone, Nano Reid, Anne King-Harman and Sylvia Cooke-Collis. The painting *Fantail Pigeons* by Louis le Brocquy was presented in 1986.

As can be clearly seen from the above account, some of the most important works in the Crawford Art Gallery's collection would not have come to Cork nor entered the national patrimony were it not for the acumen, foresight and generosity of the Friends of the National Collections of Ireland. The new exhibitions wing at the Crawford, currently under construction and scheduled for completion before the Millennium, will enable the showing of considerably more works from the Gallery's permanent collection. This is the best acknowledgement possible of the valuable, and valued, patronage of the Friends and their own loyal network of friends, patrons and benefactors.

Peter Murray is Curator of the Crawford Municipal Art Gallery, Cork

FANTAIL PIGEONS (1985) | Louis Le Brocquy (b.1916)

Crawford Municipal Art Gallery, Cork

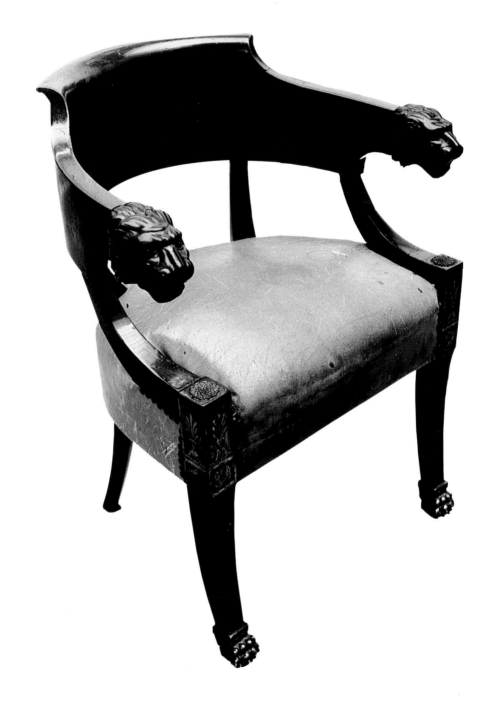

French School | CHAIR (EMPIRE STYLE)

Crawford Municipal Art Gallery, Cork

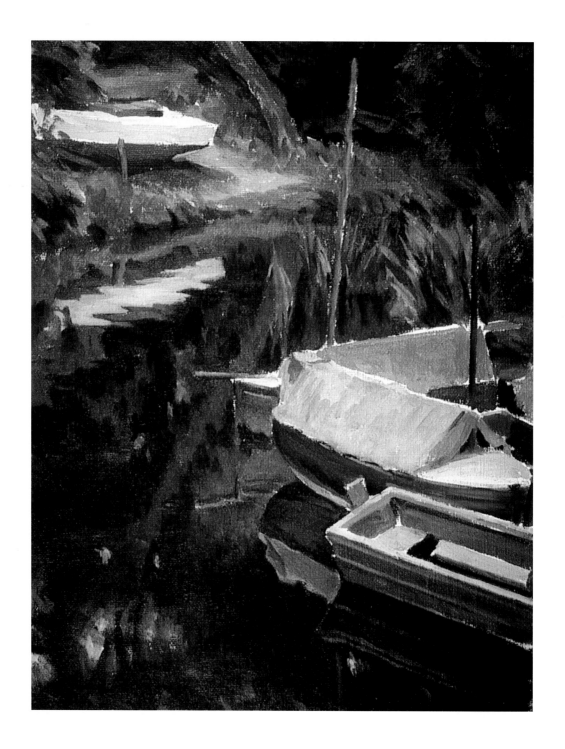

THE CREEK, TUCKTON | William Leech (1881–1968)

Drogheda Municipal Art Collection

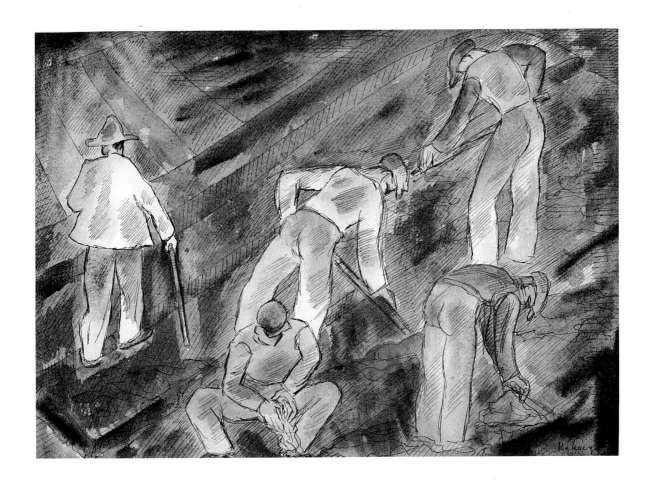

Basil Rakoczi (1908–1979) | GROUP OF MEN

Dun Laoghaire – Rathdown County Council

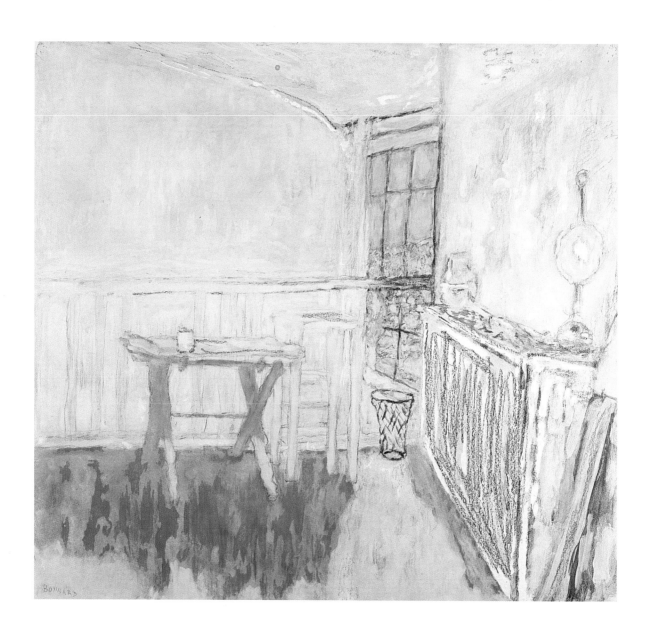

ROOM INTERIOR | Pierre Bonnard (1867-1947)

Dun Laoghaire - Rathdown County Council

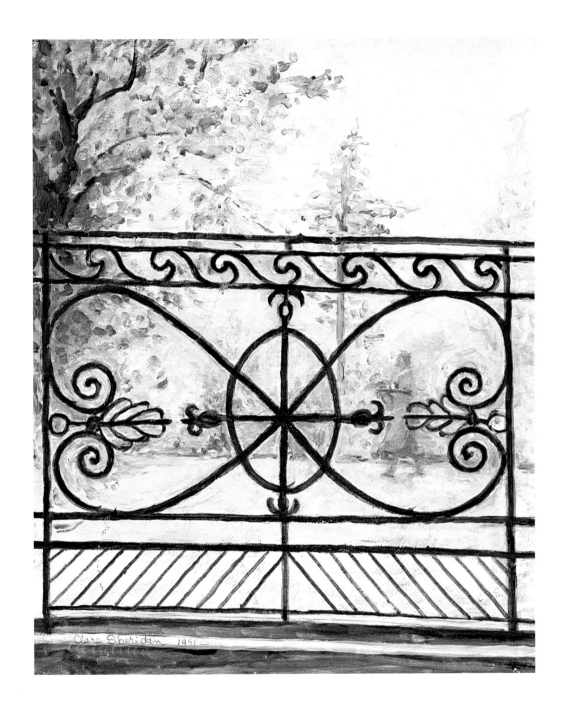

Clare Sheridan (1885–1970) | BALCONY

Galway Municipal Art Collection

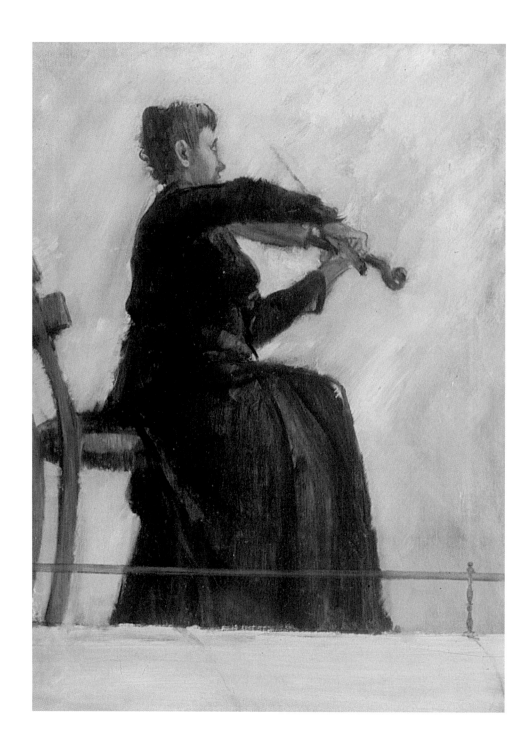

THE VIOLINIST | Derek Hill (b.1916)

Glebe House and Gallery, Donegal

Ivon Hitchens (1893–1979) | RINGED LILY (1948)

Hugh Lane Municipal Gallery of Modern Art, Dublin

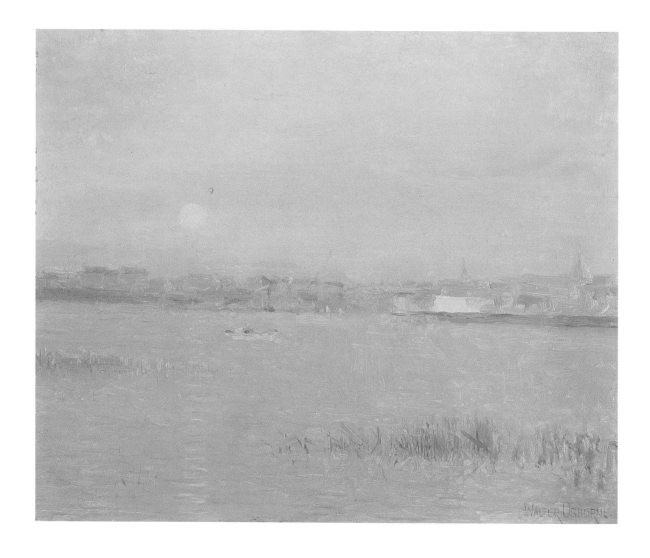

THE RISING MOON, GALWAY BAY | Walter Osborne (1859-1903)

Hugh Lane Municipal Gallery of Modern Art, Dublin

Barbara Dawson

THE FRIENDS OF THE NATIONAL COLLECTIONS OF IRELAND, *which was founded by the indomitable* IRISH ARTIST SARAH PURSER, *has a particular significance and association with* DUBLIN'S CITY ART GALLERY.

The Municipal Gallery of Modern Art, established by Hugh Lane, first opened to the public in 1908 and set a new standard of aesthetic experience in the visual arts in Ireland. It is probably the only public gallery ever set up with an expressed desire to mould a distinct identity for a native school of art, examples of which were exhibited alongside their European contemporaries.

Hugh Lane met Sarah Purser for the first time in Dublin in 1901. She was championing the cause of Irish art having already founded An Túr Gloine, a successful stained glass cooperative workshop. Fired by Sarah Purser's enthusiasm, Hugh Lane was indefatigable in his efforts to raise the profile of Irish art and in 1904 organised the first ever exhibition of Irish art at the Guildhall in London. The exhibition was a great success with over eighty thousand visitors attending in the eight week period. In the preface to the catalogue Lane outlined his ambition to form a collection of modern art in Ireland: "There are so many painters of Irish birth or Irish blood in the first rank at this moment, that extreme interest is being taken in this bringing together of sufficient specimens of their work to enable students of art to discover what common or race quantities appear through it. There is something of common race instinct in the work of all original Irish writers of to-day, and it can hardly be absent in the sister art."

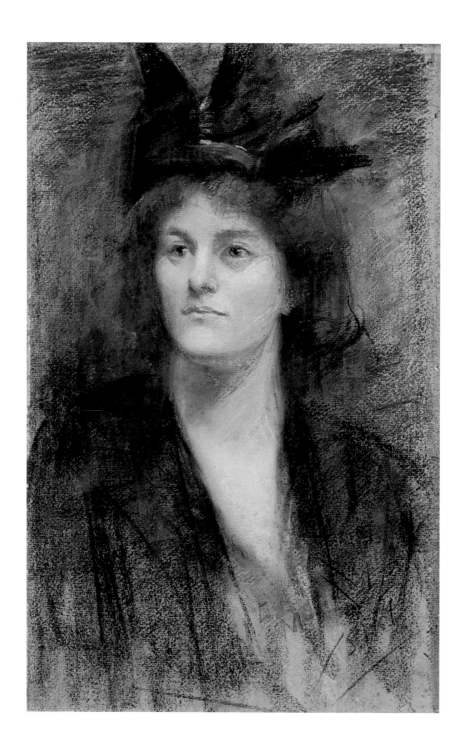

MAUD GONNE (1898) | Sarah Purser (1848-1943)

Hugh Lane Municipal Gallery of Modern Art, Dublin

Sarah Purser and her contemporaries wholeheartedly supported Hugh Lane's efforts to establish a Gallery of Modern Art and between them donated many works for the new collection. In addition to their gifts Hugh Lane purchased key paintings by a broad spectrum of Irish artists ensuring that the Irish section of the collection was representative of the period.

The original Municipal collection comprising three hundred works was largely representative of the prevailing taste of the period and includes superb examples of works by the Impressionists and their circle. Most of these were purchased by Lane including *Les Parapluies* by Renoir which ranks as one of the most famous Impressionist paintings. Manet's *Le Concert aux Tuileries,* an outdoor genre scene set in the famous Tuileries Gardens in Paris is a defining work in the advent of Modernism. *Sur la Plage* by Degas is an acknowledged masterpiece from the artist's oeuvre and its influence can be discerned in works by subsequent painters including Francis Bacon and Louis le Brocquy. In terms of style and composition, *Lavacourt Under Snow* by Monet was the most modern and daring of Lane's purchases.

When it opened in 1908 the Gallery was described by *Le Figaro* as "a museum envied by the most prosperous states and proudest cities". The Gallery was temporarily housed in Clonmell House in Harcourt Street while plans were put in place to secure a permanent home for the collection. However, the project became a focus of controversy, caught up in Nationalist politics, suspicion and a widespread lack of comprehension of the significance and value of the collection. Identifying a site for the Gallery proved almost impossible, so when the architect and friend of Lane, Edwin Lutyens suggested replacing the metal Halfpenny Bridge, which spans the Liffey in the city centre, with a stone Uffizi style gallery structure, Lane was enraptured. The problem of the site was solved. However, the City Council narrowly voted against Lutyens design at a council meeting in 1913 and so Lane removed his continental collection of thirty-nine paintings to the National Gallery, London. In his will of 1913 he bequeathed these paintings to London, but when he was subsequently appointed Director of the National Gallery of Ireland, his friends were hopeful that he would relent and return the paintings to Dublin. Although disillusioned by the lack of ongoing financial support for the Gallery Lane made a codicil to his will in 1915 returning the continental collection to Dublin, provided a Gallery was built within five years.

That same year, 1915, Hugh Lane was drowned off the Old Head of Kinsale, Cork on his return from New York. The 'Luisitania' on which he was sailing was torpedoed on May 7th and Lane's body was never found. The codicil to his will was not witnessed and so the famous debate over the continental pictures began. A British commission set up in 1924, found that Lane's paintings should remain in London and form part of the Tate Gallery's European collection.

The Friends of the National Collections of Ireland, also set up in 1924 under the leadership of Sarah Purser, resolved to champion the return of the Lane paintings to Dublin. They tirelessly lobbied the Irish Government to secure their return. In 1959 an agreement was eventually reached whereby the paintings were shared between the National Gallery, London and the Municipal Gallery, Dublin. The agreement was renegotiated in 1979 and again in 1993. Due to the efforts of the FNCI, the Gallery's collection now includes almost all of Lane's continental paintings.

Also due to Sarah Purser's efforts, the Irish Government in 1929 adopted an FNCI proposal to allocate the recently vacated Charlemont House, the former offices of the Registrar General, for a Municipal Gallery of Modern Art. Charlemont House, formerly the home of the 1st Earl of Charlemont, was designed by William Chambers and is one of the finest examples of domestic architecture in Dublin. After extensive renovations carried out by the then city architect Horace T. O'Rourke, the Gallery was formally opened by President de Valera in 1933.

Through their untiring support of the arts, the FNCI displayed an enlightened appreciation of the importance of the role of a vibrant visual arts practice in establishing a cultural identity, which was particularly significant in the newly founded State. Their remarkable perception in realising what a first rank, modern art collection would do for Ireland's cultural self esteem led them to acquire and present to the Municipal Gallery artworks of international and national significance. This was crucial for the future potential success of the Municipal Collection as it received no funding from the city to acquire artworks. During the 1940's the Gallery was fortunate to receive funding from the FNCI. Important additions to its French collection, including a very fine street scene, *Boulevard de Clichy* by Pierre Bonnard, painted c.1911; *Opium* by Maurice de

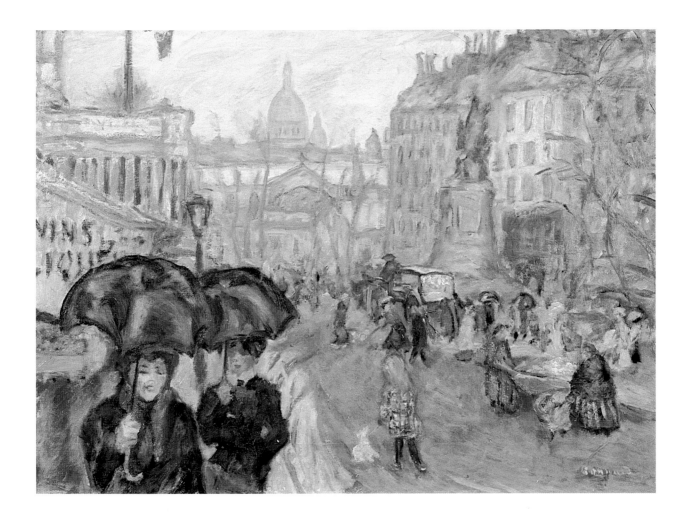

Pierre Bonnard (1867–1947) | BOULEVARD DE CLICHY (c.1911)

Hugh Lane Municipal Gallery of Modern Art, Dublin

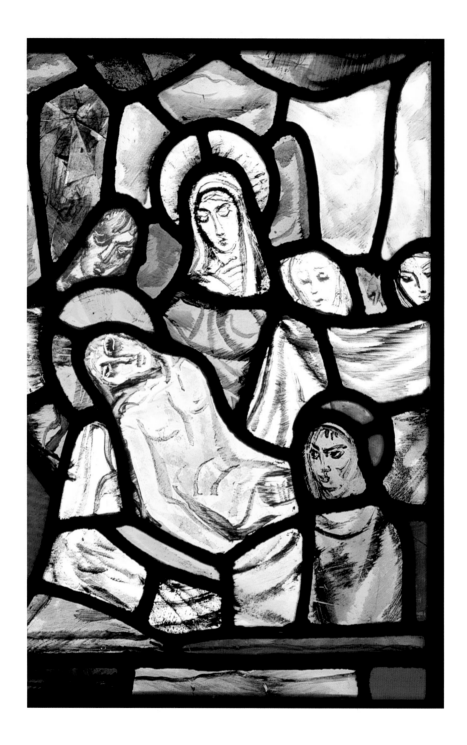

THE DEPOSITION (c.1953) | Evie Hone (1894-1955)

Hugh Lane Municipal Gallery of Modern Art, Dublin

Vlaminck, which is an excellent example of the artist's brief experimentation with Cubism; and the controversial Rouault, *Christ and the Soldier* which was rejected by the Gallery's Arts Advisory Committee. With a total lack of appreciation both of the importance of the gift and the stature of the artist, they objected to Rouault's modern depiction of religious iconography, particularly the composition of the Christ figure. The Committee relented after the painting went on display in Maynooth College where the priests were only too happy to exhibit Rouault's work. More recent gifts through the FNCI have ensured that the contemporary identity of the collection has been maintained. Joseph Albers' *Homage to the Square - Aglow 1963,* presented by the FNCI in 1970, is a fine example of Minimalism, in which he explores the relationship between colour composition and spiritual expression.

Continuing his preface to the 1904 exhibition catalogue Hugh Lane wrote "… for it is one's contemporaries that teach one the most. They are busy with the same problems of expression as oneself, for almost every artist expresses the soul of his own age." But for the vision of the FNCI the Municipal Collection would have failed in its raison d'etre as a primary focus for successive generations of art practice.

Barbara Dawson is Director of the
Hugh Lane Municipal Gallery of Modern Art, Dublin

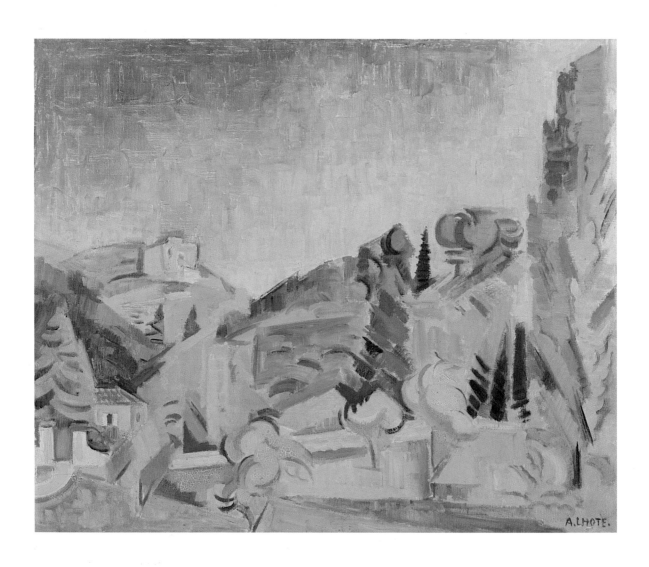

LANDSCAPE (c.1930–35) | André Lhote (1885–1962)

Hugh Lane Municipal Gallery of Modern Art, Dublin

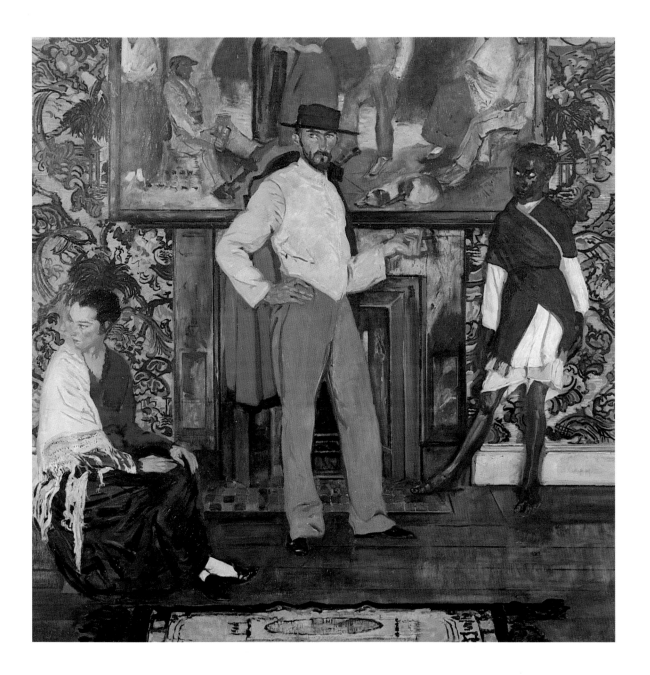

Seán Keating (1889-1977) | CONRADESQUE

Hugh Lane Municipal Gallery of Modern Art, Dublin

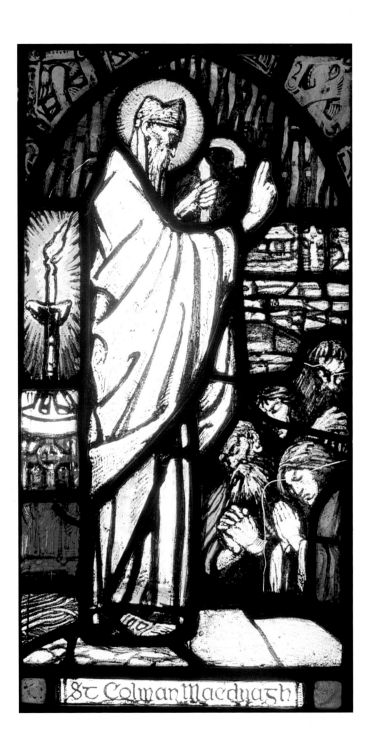

SCENES FROM LIFE OF ST. COLMAN MACDUAGH | Wilhelmina Geddes (1887-1955)

Hugh Lane Municipal Gallery of Modern Art, Dublin

Jack B. Yeats (1871–1957) | THE BALL ALLEY (c.1927)

Hugh Lane Municipal Gallery of Modern Art, Dublin

PORTRAIT OF THE O'DONOGHUE OF THE GLENS | Leo Whelan (1892-1956)

Heraldic Museum, Dublin

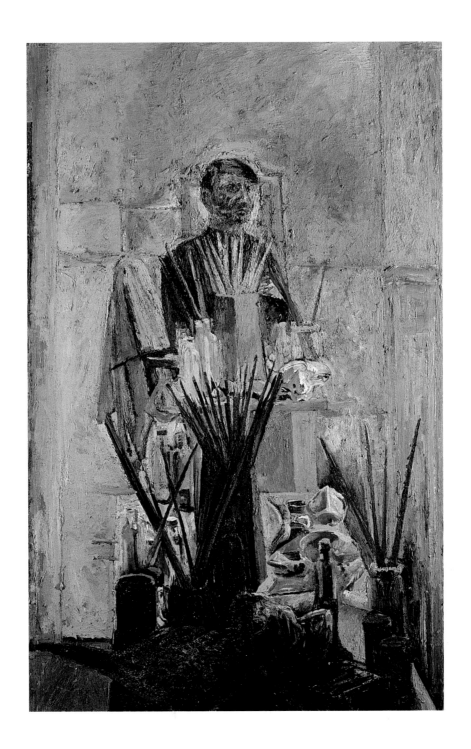

Patrick Swift (1927-1983) | SELF PORTRAIT IN THE STUDIO c.1959

Irish Museum of Modern Art, Dublin

A VIEW OF BALLYBUNION | William Henry Bartlett (1809-1854)

Kerry County Library

Bea Orpen (1913-1980) | CUTTING TURF, ANNAGHMAKERRIG

Monaghan County Museum

PORTRAITS OF LADY CATHERINE AND
LADY CHARLOTTE TALBOT (1679)

John Michael Wright (1617–1694)

National Gallery of Ireland, Dublin

Adrian Le Harivel

TO DATE THE NATIONAL GALLERY OF IRELAND *has received* 47 PAINTINGS, 133 PRINT ROOM ITEMS *(including 105 Alicia Boyle sketchbooks),* 4 STAINED GLASS PANELS AND A SCULPTURE THROUGH THE FNCI. These span the seventy-five years of its existence, and range from a School of Jacopo Bassano *Procession to Calvary*, once in the Earl of Portarlington's collection, to a recent work by Anne Yeats.

There is a choice selection of eighteenth century subject paintings. James Barry's refined treatment of *The Death of Adonis (c. 1775)* blends an autumnal landscape with the grief of Venus for her lover. His sketch of *Jacomo and Imogen (c. 1790),* from Shakespeare's *Cymbeline,* is a study for the vast canvas now in the Royal Dublin Society. *Cupid and Psyche in the Nuptial Bower (1793)* by Hugh Douglas Hamilton was purchased and offered by the FNCI as 'an interesting example of his work' (letter in dossier). It is one of Hamilton's few large-scale mythological subjects, with a sensibility in the treatment of young love on a par with his neoclassical contemporaries. Conceived when Hamilton was in Italy, there are resonances both of Antique art and sculpture by his friend, Antonio Canova. Proudly signed and inscribed 'Dubl.', he was to lament that there were only commissions for portraiture at home. Both picture and frame were successfully conserved during 1996.

Flemish artist Pieter de Gree spent his last five years in Ireland, encouraged to visit by banker David La Touche. He painted *Bacchanal with putti (c. 1785),* a typical *trompe l'oeil* decorative relief, for his son, Peter La Touche. It is first recorded at

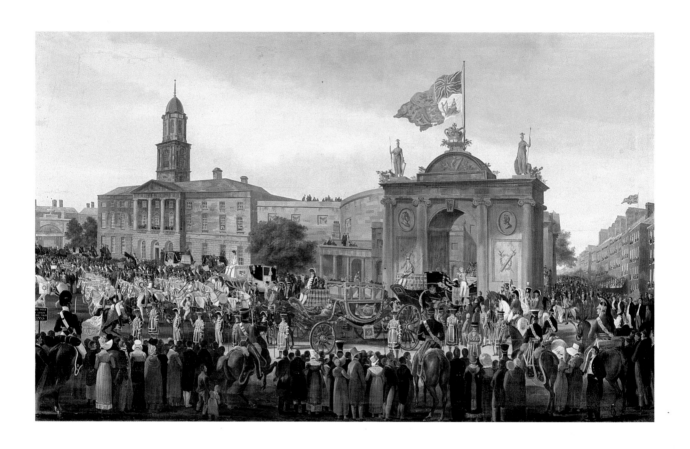

THE GRAND ENTRY OF GEORGE IV INTO DUBLIN
17TH AUGUST 1821

William Turner de Lond (fl.1767–1826)

National Gallery of Ireland, Dublin

Luggala, his Co. Wicklow hunting lodge. Conversely, George Barret's *Stormy Landscape (c.1760)* is a romanticised nightscape and derived from a painting then attributed to Salvator Rosa.

Influences from Aert van der Neer, Claude Lorrain and George Morland are seen in late eighteenth century paintings on glass by Thomas Jervais (*View of an Estuary by moonlight, c.1785; Pastoral Landscape*) and Richard Hand *(Halt outside an Inn, 1785)*. These were originally installed in windows of coloured glass at Lucan House. Both artists learnt their technique from chemists and were part of the revival of stained glass by Horace Walpole and his circle.

Sir Alec Martin of Christie's was a member of the Board of Governors and Guardians, and close friend of Sir Hugh Lane. On four occasions he presented portraits by Irish artists. Nathaniel Hone's *Self-portrait (1750s)* against an easel is almost a solicitation for employment. Like Rembrandt, whom he admired, Hone painted himself regularly, both in everyday and fancy dress, providing a commentary on his social aspirations, if no great psychological insight. *Susanah Walker (1760)* by Thomas Frye has lost a little surface finish, but her elegance and jewellery recall Frye's celebrated mezzotint heads. Thomas Hickey was on his first extended visit to India in 1787 when he painted the ravishing *Indian Lady, perhaps Jemdanee (1787),* bibi of lawyer William Hickey, seated on a carpet, with sweetmeats in silver vessels. Composer *Dr Francis Hutcheson (c.1780)* was recorded by Robert Hunter, who was fashionable in Dublin to the 1780s. For many years the sitter was confused with the Irish philosopher of the same name.

With more charm than sophistication, Jeremiah Barrett, active in the 1760s, painted *Master Daly (1765)*, aged 1³/₄, and an unknown artist the scowling visage of *Jonathan Swift*. A mid-eighteenth century *Profile portrait of a young boy* by Nathaniel Bermingham appears to be a form of novelty pastel an artist specialising in portraits and coats of arms cut in paper and vellum.

The Talbot Sisters (1679), a rare seventeenth century double children's portrait by John Michael Wright, was purchased from Malahide Castle with the aid of FNCI funds. However sumptuous the costume, their mother's recent death, imprisonment of their father, and the fellow Catholic artist's own precarious situation, indicate it was not conceived in happy circumstances. Turner de Lond painted several Irish street scenes, but *The Grand Entry of George IV into Dublin,*

17th August 1821 is on a scale appropriate to the spectacle arranged for the King's arrival outside the Rotunda Hospital. In the military band instruments can be precisely identified, though no key was engraved of the notables amongst the bystanders, as for Joseph Haverty's painting of the same scene. Turner de Lond exhibited his work, with twenty three other pictures, that October, in Limerick.

Patrick Redmond is an engaging image by Richard Rothwell, who hankered more for acknowledgement as a subject painter. *Thomas Francis Meagher* by the Gallery's first Director, George Mulvany, seems equally benign, hardly conjuring the Young Irelander deported after the 1848 rising and subsequently an American Civil War Commander and acting-Governor for lawless Montana. Sarah Purser's grave portrait of the executed *Roger Casement (1927)* is certainly iconic, yet hints at his vulnerable nature. There is vibrant colour in her tiny head of Brendan Behan's mother, the doughty *Kathleen Behan, (The Sad Girl, 1923),* which remained in Sarah Purser's home.

Purser's early days as an art student in Paris are recalled by her friend, Swiss artist, Louise Breslau's stylish portrayal of *Berligot Ibsen (1889).* The sitter was the wife of writer Henrik Ibsen's son and her portrait presented in memory of Breslau. Among contrasting depictions of women are Henry Tonks' *The Toilet (1936),* the third version he painted of the subject, and the jaunty *Mrs Pamela Grove (1943/45),* wife of an Irish banking agent, by Augustus John. She was one of many Irish sitters, and reflects the less angular style of this period. *Saidbh Trinseach* was given a dreamy Celtic Revival appearance by George (AE) Russell, in his recognisable semi-Impressionist technique.

Sir Alec Martin also presented two modern paintings. *An Allegory (1925)* by Seán Keating offers various interpretations of the artist's attitude to modern Ireland. William Orpen's *Trees at Howth (1910)* depicts the lane to the Bellingham home at Howth in sombre colouring of the Barbizon School. France itself is represented in *Landscape* by Charles Daubigny, a freely worked oil sketch of cattle by a river, while Evie Hone's striking winter landscape, *Snow at Marlay (c.1947),* portrays the park by her south Dublin studio. The earliest landscape from the FNCI is the riverside *Landscape with figures (?1651)* by Roelof van Vries. Active in Haarlem and Leiden, he was strongly influenced by Jacob van Ruisdael, and this is one of his few dated works (though the digits are unclear).

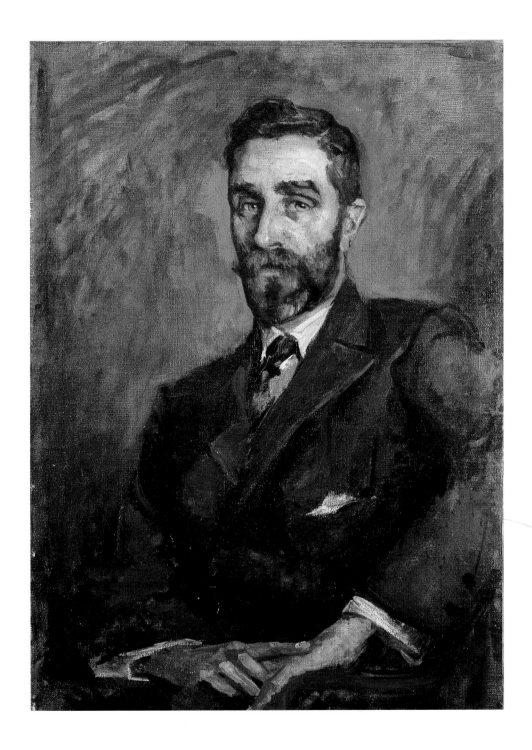

Sarah Purser (1848–1943) | PORTRAIT OF ROGER CASEMENT (1927)

National Gallery of Ireland, Dublin

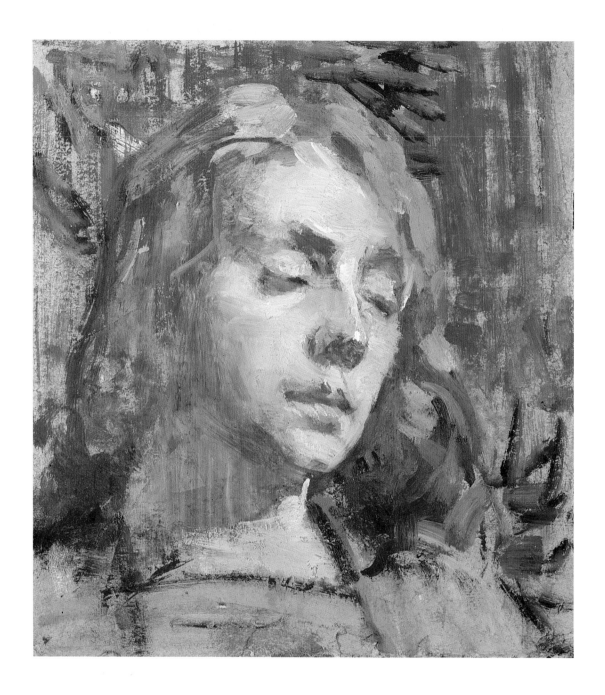

THE SAD HEAD, KATHLEEN BEHAN (1923) | Sarah Purser (1848-1943)

National Gallery of Ireland, Dublin

The prints and drawings collection has been enhanced by additions like *The Hessel Apartment, Rue de Rivoli, Paris (1903),* an intimiste interior in brushed pastel and distemper *(peinture à la colle)* by Edouard Vuillard, the jazz age *Three Musicians (1915/20)* by Gino Severini, modernist Frances Hodgkins' *Boats on a river,* and Henri Matisse's graceful *Dancer reflected in the mirror (1927)* lithograph. The pair of full-size painted cartoons by Evie Hone for stained glass windows at Kingscourt, Co. Cavan (c.1947-48), were followed by a key study for the Eton Window (1950). It was bequeathed by her sister, together with *Heads of Two Apostles (c.1952),* a full-size sketch on glass. Jean Lurçat's surreal *Lunar Landscape* in gouache, and South African Francesco Cuarain's playful *Two Seals (1934)* in black basalt, are by less known figures.

Three early pencil studies of figures at work by Walter Osborne show his academic style, in contrast to more schematic later drawings. *Lady reading a book (1824)* by William Mulready is for an unidentified subject, while *Seated Male Nude (1860),* in black and red chalk, evidences the high level of draughtsmanship maintained through his career, with continuing visits to the life class. Miniature painter John Comerford's delicate handling and breadth of finish is seen well in *Mrs Coote (1804).* The watercolourist George Holmes (fl.1789-1843) is represented through a 75th Anniversary gift of *Swords Castle, Co. Dublin (?1790s),* which was curiously sanitised of Irish genre figures when engraved for Brewer's *Beauties of Ireland (1824).* Alicia Boyle (1908-1997) bequeathed her sketchbooks from 1931-96 giving an unmatched insight into her development. This was complemented by six paintings of the 1960s-80s. Oil studies and watercolours by Clare Marsh (1875-1923) were presented by the niece of artist Mary Swanzy.

Old Master sheets comprise Giuseppe Passeri's *?Silenus and King Midas* drawing, *Cavalry fighting* by Francesco Simonini and putti in an *Allegory of Winter* by eighteenth century decorative painter Jacob de Wit.

The Yeats collection has greatly benefited from the FNCI. Susan Mary 'Lily' Yeats bequeathed family portraits of her mother and herself. In these, her father John Butler Yeats responded to very different sitters. The tenseness of *The artist's wife (c.1875)* contrasts with the directness of gaze of his daughter (1900-01), and subtle play of colour in the semi-opaque dress brushwork. The head of *Lady Gregory (1903)* is less dominant than in life and may reflect the impact of producing

twenty head and shoulder portraits of public figures for Hugh Lane's modern gallery. With actor *J.M. Kerrigan (1911),* the medium of pencil expressively captures his features, as in other such drawings. Max Beerbohm's amusing caricature of the young *W.B. Yeats (c.1895)* shows his then habitual pince-nez, much attenuated like his head, floppy hair and spindly arms.

Two seminal works by Jack B. Yeats came from the bequest of Mrs Julia Egan. The graphic *Before the Start (1915)* is of a Galway point-to-point, and *Many Ferries (1948),* a memory of the trip with John Synge to Divinish Island. More recently, the FNCI marked the opening of the Yeats Museum in presenting *Green cloth floating (1993)* by Anne Yeats, wherein an aqueous world is conjured by flowing colour and application of muslin.

It can be seen that the works directed by the Friends of the National Collections of Ireland to the National Gallery have much enhanced the collection, particularly the Irish School. This is in no small part due to the discernment of those administering the Friends.

Adrian Le Harivel is Curator of British and Dutch Paintings
at the National Gallery of Ireland, Dublin

Michael Stapleton (c.1740–1801) | CEILING IN VENUS DRAWING ROOM
BELVEDERE HOUSE

National Library of Ireland, Dublin

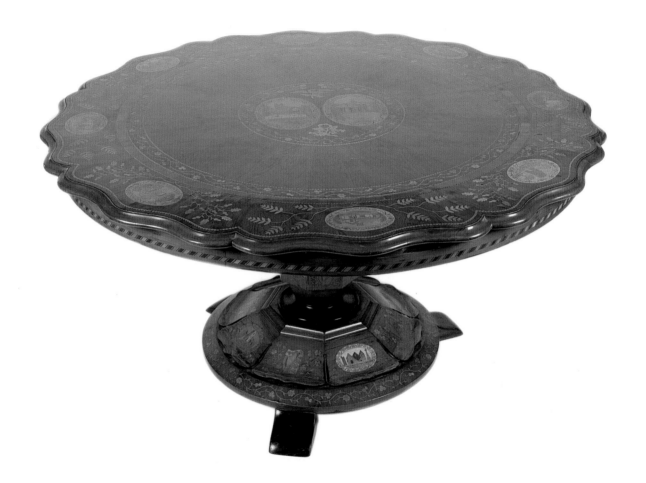

KILLARNEY TABLE

National Museum of Ireland, Dublin

BOG OAK NECKLACE SET
(19TH CENTURY)

National Museum of Ireland, Dublin

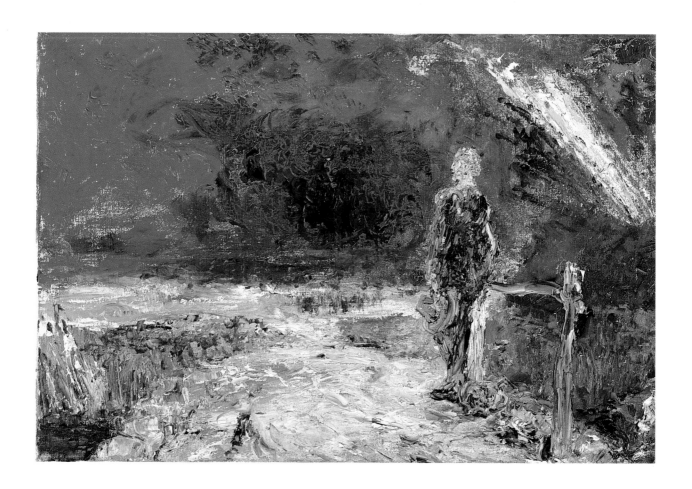

THE SEA AND THE LIGHTHOUSE | Jack B. Yeats (1871–1957)

Niland Gallery, Sligo

John van Nost (Younger) (fl.1750-1787) | EQUESTRIAN STATUE OF GEORGE II – MAQUETTE

Old Dublin Society, Dublin

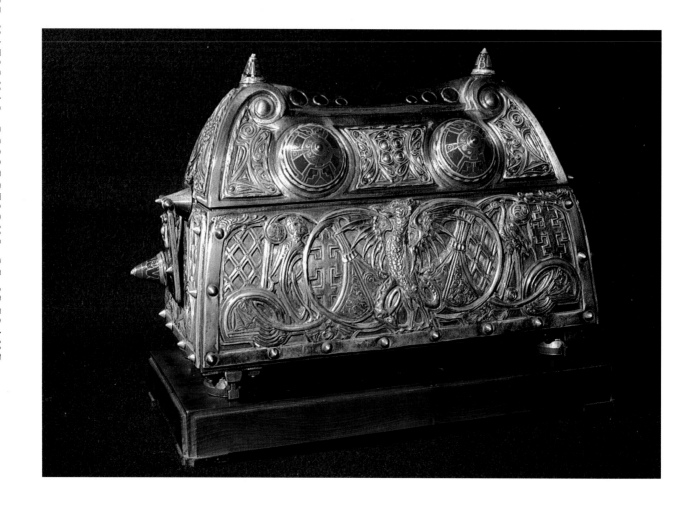

SENATE CASKET | Mia Cranwill (1880–1972)

Royal Irish Academy, Dublin

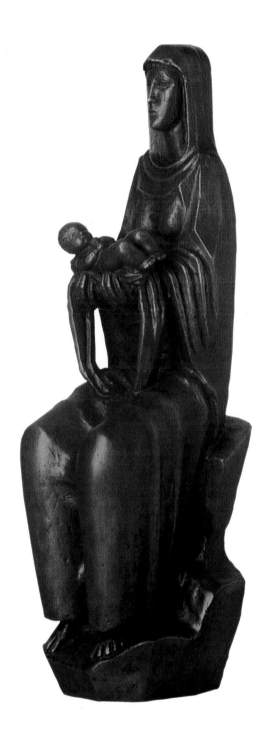

Frederich Herkner (1902–1986) | MOTHER AND CHILD

St. Patrick's College, Maynooth

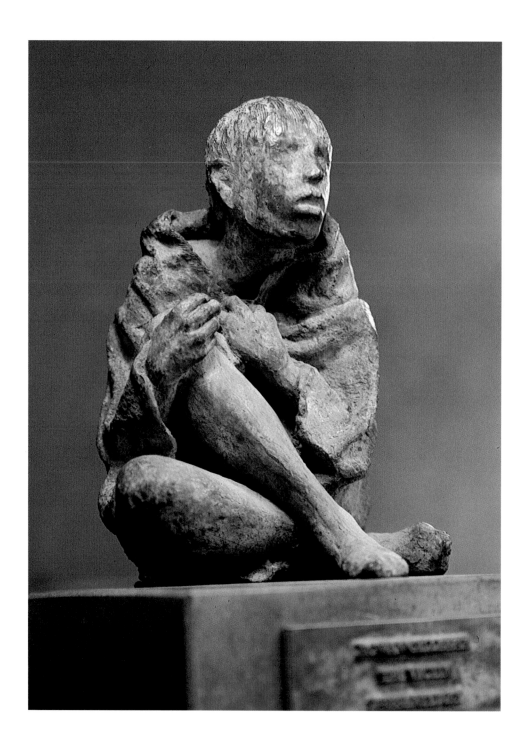

THE VICTIM | Rowan Gillespie (b.1953)

Tipperary South Riding County Museum, Clonmel

John B. Yeats (1839-1922) | PORTRAIT OF JOHN O'LEARY

Tipperary South Riding County Museum, Clonmel

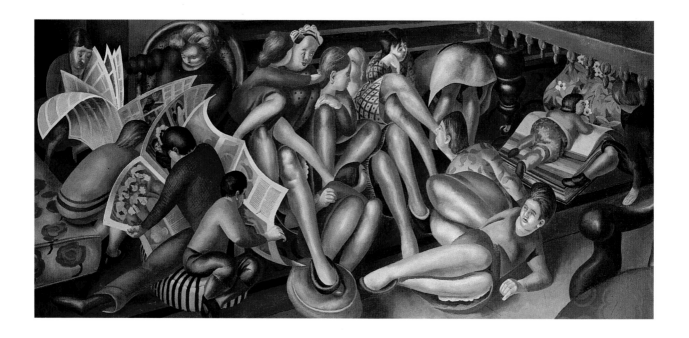

SCENE FROM THE MARRIAGE AT CANA
IN GALILEE (1935)

Sir Stanley Spencer (1891-1959)

Ulster Museum, Belfast

Martyn Anglesea

SINCE ITS FOUNDATION IN 1924, THE FRIENDS OF THE NATIONAL COLLECTIONS OF IRELAND, *entirely supported by* VOLUNTARY SUBSCRIPTIONS, DONATIONS AND LEGACIES, *has been able to give over* FIVE HUNDRED WORKS OF ART TO PUBLIC COLLECTIONS ALL OVER THE ISLAND OF IRELAND. Northern museums in Belfast, Armagh and Enniskillen have all benefited. In 1928 the Belfast Museum and Art Gallery, then a municipal museum, opened its doors to the public on its new site in the Botanic Gardens, Stranmillis. As early as this it received from the FNCI an impressive drawing of *Male Figure Studies* by Sir William Orpen (1878-1931), who was still alive at the time. As in most of Orpen's mature drawings, the line is direct and economical. The fact that this is signed simply "ORPEN" in upright capitals suggests that it is a rather late drawing rather than a student life study.

Over the following seventy years the Friends have donated or assisted in the purchase of thirty-five items now in the collections at Belfast. In 1961 the Belfast Museum was made a national institution by Act of Parliament and re-named the Ulster Museum. Currently, in 1998 a merger was set in motion which reconstitutes the three Government-funded museum sites here as the National Museums and Galleries of Northern Ireland, with a single Board of Trustees. The other two sites are the Ulster Folk and Transport Museum at Cultra and the Ulster-American Folk Park near Omagh.

In 1939 the Honorable Bryan Guinness gave the FNCI an outstanding New Testament painting by the controversial English painter, Stanley Spencer of Cookham, *The Marriage at Cana* (1935). Spencer conceived his biblical scenes in modern dress, and in the location of his native Cookham-upon-Thames. This was allocated to Belfast and made a most welcome addition to the small but developing

IRISH MARKET SCENE | Letitia Hamilton (1880-1964)

Ulster Museum, Belfast

collection of contemporary British Art which had become a unique feature of the Belfast Museum under its then Keeper of Art, the poet John Hewitt. The Museum had already bought Spencer's *Betrayal* (1922-3) in 1929. Spencer had a special affection for Belfast, which he visited frequently, as his elder brother Harold worked as a music teacher here. He found a Belfast patron in Zoltan Lewinter-Frankl, a Viennese Jewish refugee from the Nazis, who managed a textile factory in Newtowriards and built up an important private collection.

A fine bronze bust of an Indian model, *Ahmed,* by the American-bom sculptor Sir Jacob Epstein, was given to Belfast by the FNCI in 1956. The Ulster Museum now has two bronze busts and one drawing by Epstein, a valuable component of one of the most distinguished collections of modern sculpture in Ireland. *An Irish Market Scene* by Letitia Hamilton (1880-196 1) was given in 1959, part of a bequest from Dr R I Best, which also included a picture by Letitia's sister Eva Hamilton. The Friends have also contributed works of applied art, particularly silver, for example the spectacular *Loftus Cup* made for Adam Loftus from the Great Seal of Ireland, acquired for Belfast in 1956. A small eighteenth century Irish silver salver was given in 1963. The silver *Cavan Mace* is at present on long-term loan to the County Museum in Cavan. During the period of Anne Crookshank's tenure of the Keepership of Art, 1958-66, the collections of 20th century international painting and sculpture were developed as never before. Paintings by Williiam Scott, Roger Hilton and Terry Frost were bought from London galleries in the early 1960s with aid from the FNCI, increasing the prestige of the collection of contemporary art. These three artists ranked then as the foremost abstract painters in Britain, still taking their inspiration from Paris and continental Europe, while the younger generation tended to look to North America. Among this group is one of the long series of pictures by the Welsh painter Ceri Richards (1903-71), on the theme of *la Cathédrale Engloutie (Dialogue du Vent et de la Mer),* bought in 1963, again with help from the FNCI. The haunting motif of the coastal inundation, the drowned city with its cathedral bells sounding under the waves, recurs in the folklore of west Wales and Brittany, and was the inspiration of some music by Debussy. The same year the FNCI contributed to the purchase of a little landscape by the early seventeenth century Roman painter Agostino Tassi (1565-1644).

A drawing of the writer *George Russell ("AE")* on his deathbed, by Séan O'Sullivan RHA (1906-64), was donated in 1974. Elected, RHA at the early age of twenty-five, O'Sullivan is best known for a long series of charcoal portraits of

Irish personalities, thirty-nine of which are in the National Gallery of Ireland. George Russell, born in Lurgan, Co Armagh, moved to England after his wife's death in 1932, and died in Bournmouth, Dorset, in 1935. This drawing is one of three commissioned from O'Sullivan by C P Curran, whose daughter, Mrs Elizabeth Solterer of Arlington, Virginia, gave it to the FNCI. 1982 saw the donation of a large, sombre, romantic watercolour of *Bladon* (1946) by Sir John Piper, depicting the park of Blenheim Palace in Oxfordshire. This is one of a number of gloomy parkland scenes which Piper painted throughout the 1940s. Piper lived not far away from Blenheim, at Fawley Bottom, near Henley-on-Thames. This watercolour was shown in Dublin at the Irish Exhibition of Living Art in 1951, and subsequently acquired by the Derry-bom painter Norah McGuinness (1903-1980), who bequeathed it to the Friends of the National Collections of Ireland, "with the hope that it be lent from time to time to Derry when a suitable gallery becomes available". It was given to the Ulster Museum in memory of Norah McGuinness, and was included in a travelling exhibition which toured the United States between 1989 and 1991.

A second Orpen drawing, of a female nude, came in 1963, given in memory of Professor Thomas Bodkin (1887-196 1), one of Orpen's earliest supporters. Bodkin was Director of the National Gallery of Ireland 1927-35, then Barber Professor of Fine Art and first Director of the Barber Institute in the University of Birmingham. He was involved with Orpen over the matter of the Hugh Lane Bequest. The oil painting *Venus Anadyomene* by James Barry (1741-1806) also came to Belfast at this time from the Bodkin collection. The Friends of the National Collections of Ireland have provided the Ulster Museum with many major works of art, some of which cannot be moved, such as the Hopton Wood stone *Mother and Child* (1930) by Edward Bainbridge Copriall (1903-73), which arrived in 1941 and is now in the entrance hall of the Museum. Other distinguished acquisitions include works by William John Leech, Paul Henry, Father Jack Hanlon, Evie Hone and her teacher André Lhote. In 1973 the FNCI contributed £500 towards the purchase of a very rare work, the only identified painting by Thomas Bate, a portrait of *Lord Coningsby* dated 1692 Their latest donation, in 1997, was a painting of *MacArt's Fort,* overlooking Belfast by William Hollywood, a Lancashire man who lived in Belfast for many years, and who was wellknown as a commercial artist and ornithological painter. This was given by Mr Nicholas Burke of Washington D.C., in memory of his mother.

Martyn Anglesea is Keeper of Fine Art
at the Ulster Museum, Belfast

John Piper (b.1903) | BLADON (1945)

Ulster Museum, Belfast

LA CATHÉDRALE ENGLOUTIE | Ceri Richards (1903–1971)
(DIALOGUE DU VENT ET DE LA MER) (1962)

Ulster Museum, Belfast

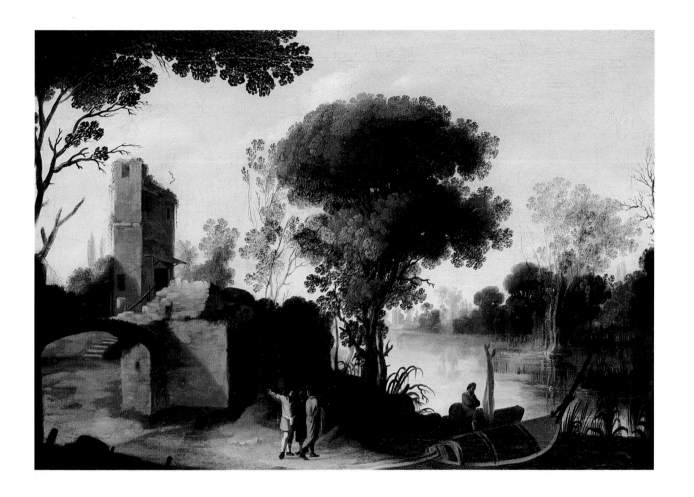

Agostino Tassi (1565-1644) | LANDSCAPE WITH FIGURES

Ulster Museum, Belfast

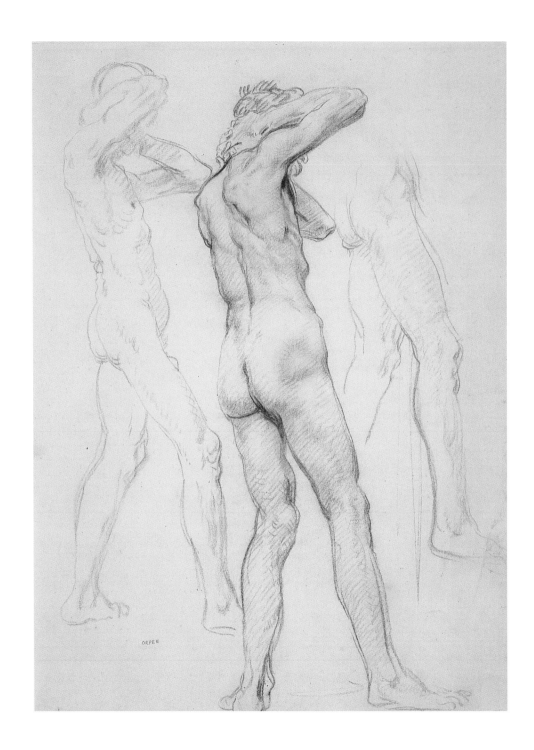

MALE FIGURE STUDIES | Sir William Orpen (1878-1931)

Ulster Museum, Belfast

Seán O'Sullivan (1906-1964) | GEORGE RUSSELL (AE) (1867-1935)
ON HIS DEATHBED (1935)

Ulster Museum, Belfast

18TH CENTURY SILVER SALVER

Ulster Museum, Belfast

GIFTS *from* THE
FRIENDS OF THE NATIONAL
COLLECTIONS OF IRELAND

All measurements in centimetres (height first) ⓔ - *exhibited at 75th Anniversary Exhibition*

RHA - RHA GALLAGHER GALLERY HLMGMA - HUGH LANE MUNICIPAL GALLERY OF MODERN ART

Abbey Theatre
 Augustus John HEAD OF W. B. YEATS BRONZE H 48.26 FNCI GRANT

Aer Rianta, Shannon Airport
 1993 Pres Ukranian Academy CATTLE IN A STORMY LANDSCAPE LITHOGRAPH DR.T. RYAN

Armagh County Museum
 1969 Jack P. Hanlon STRANGE FRUIT (1964) WATERCOLOUR ON PAPER 56 x 76

 1963 Philip Hussey PORTRAIT OF WILLIAM LODGE OIL ON CANVAS 124 x 99 FNCI GRANT

 1966 James Sleator PRHA PORTRAIT OF MRS. MACNAMARA OIL ON CANVAS 119 x 91 FNCI GRANT

Athlone County Library
 1998 Robert Enraght-Moony THE SEASONS TEMPERA ON BOARD 52.5 x 39

Butler Gallery Kilkenny
 1992 Patrick Collins A MAN ON A COUNTRY ROAD OIL ON BOARD 43.5 x 54 LADY DUNSANY

RHA ⓔ 1980 Gerard Dillon FIGURES IN A CONNEMARA LANDSCAPE OIL ON CANVAS 29 x 30 GROVE BEQ.

 Stella Frost ACHILL ROCKS WATERCOLOUR 25 x 35

 Stella Frost TITLE UNKNOWN WATERCOLOUR 27 x 39

 Letitia Hamilton FLOWERS WATERCOLOUR

RHA ⓔ Evie Hone BLUE ABSTRACT GOUACHE 36 x 29

 1973 Evie Hone COMPOSITION GOUACHE 19 x 24

 1986 Albert Irvin CALEDONIA ACRYLIC 120 x 84 MISS E YEATS BEQ.

RHA ⓔ 1978 Mainie Jellett FIGURES (1946) WATERCOLOUR 39 x 29

 1982 Ferenc Martyn ABSTRACT WATERCOLOUR 29 x 39

RHA ⓔ 1985 Paul O'Keeffe SCULPTURE STEEL 290 x 195 x 195

 1981 Clifford Rainey ST. SEBASTIAN MIXED MEDIA 38 x 58 x 39 FNCI GRANT

RHA ⓔ 1978 Sir William Rothenstein PORTRAIT OF W. B. YEATS PENCIL DRAWING 22 x 16 JACK B.YEATS

 George Russell THE PHOENIX PARK 1885 WATERCOLOUR 39 x 46

 Gino Severini MUSICIANS PRINT

 1978 Mary Swanzy GROUP 1943 OIL ON CANVAS 72 x 58

Central Library Services
 1987 John Henry Bishop UNTITLED STILL LIFE WATERCOLOUR 33 x 24.8 MRS. PLANT

 1987 John Henry Bishop UNTITLED VIEW WATERCOLOUR 24.5 x 33 MRS. PLANT

 1987 John Henry Bishop UNTITLED VIEW WATERCOLOUR 28.5 x 22 MRS PLANT

Chester Beatty Library, Dublin

RHA ⓔ 1995 Romio Shrestha SHAKYAMUNI BUDDHA STONE COL. ON CANVAS 128 x 89

Cobh, U.D.C Co. Cork,

RHA ⓔ 1953 Jerome Connor LUSITANIA MEMORIAL – GRIEVING FISHERMEN BRONZE

Cork Public Museum

1979 Wm. Heyland, Cork 1810 GEORGE III MILK JUG SILVER 10.16CMS HIGH

RHA ⓔ 1979 Wm. Heyland (c.1795) GEORGE III OBLONG MILK JUG SILVER 14.60CMS HIGH

1979 John Humphreys/Hillery GEORGE II SUGAR BOWL – CORK C. 1780 SILVER 11.43CMS DIA

1985 Wm.Reynolds – Cork c.1757 COFFEE POT SILVER 29CMS HIGH

RHA ⓔ 1979 TOBACCO BOX – c.1835 SILVER 11.43CMS WIDE

RHA ⓔ 1979 "UNION" DECANTER EARLY 19C GLASS 26CMS HIGH

Crawford Municipal Art Gallery

1989 George M.W. Atkinson A BOATING PARTY IN CORK HARBOUR 1840
OIL ON CANVAS 60.9 x 91.4 FNCI GRANT

RHA ⓔ 1989 Michael Ayrton THE MINOTAUR BRONZE 26 x 23.5 x 31 FNCI GRANT

RHA ⓔ 1956 James Barry PORTRAITS OF BARRY & BURKE IN THE CHARACTERS OF ULYSSES AND HIS
COMPANION FLEEING FROM THE CAVE OF POLYPHEMUS C1876 OIL ON CANVAS 127 x 102

RHA ⓔ 1987 James Brenan PATCHWORK 1891 OIL ON CANVAS 25 x 30.5 FNCI GRANT

1981 Jan Breughel (follower) COUNTRY SCENE WITH WAGON OIL ON COPPER 31.75 x 38.73 GROVE BEQ.

RHA ⓔ 1986 Louis le Brocquy FANTAIL PIGEONS (1985) OIL ON CANVAS 53.5 x 64.5

1980 Alex Chisholm PORTRAIT OF FR. THEOBOLD MATTHEW

1974 Sylvia Cooke-Collis CAHIRMEE FAIR ACRYLIC ON BOARD 46 x 62 COOKE-COLLIS BEQ.

1974 Sylvia Cooke-Collis FESTIVAL SCENE OIL ON CANVAS 141 x 106 COOKE-COLLIS BEQ.

1974 Sylvia Cooke-Collis GLENCAR TREES GOUACHE ON PAPER 60 x 36 COOKE-COLLIS BEQ.

1974 Sylvia Cooke-Collis POTTERS SHED OIL ON BOARD 39 x 55 COOKE-COLLIS BEQ.

1974 Sylvia Cooke-Collis STILL LIFE WITH CHINESE MANDARIN OIL ON CANVAS 91 x 76 COOKE-COLLIS BEQ.

RHA ⓔ 1960 French School CHAIR (EMPIRE STYLE) WOOD/LEATHER UPHOLS. 80 x 51

1958 Evie Hone AT GLENCORMAC, CO. WICKLOW GOUACHE ON PAPER 26 x 36.5 A.F CONNELL BEQ.

1958 Evie Hone GARDEN, CO. LOUTH GOUACHE ON PAPER 35 x 25 A.F CONNELL BEQ.

1958 Evie Hone HEAD OF A BOY WATERCOLOUR ON PAPER 14 x 8.5 A.F CONNELL BEG.

1958 Evie Hone IN THE WOODS AT MARLEY GOUACHE ON PAPER 47.5 x 40.5 A.F CONNELL BEQ.

1958 Evie Hone SEATED FIGURE WATERCOLOUR ON PAPER 13.7 x 8.5 A.F CONNELL BEQ.

1958 Evie Hone ST. HUBERT STAINED GLASS 37 DIAM A.F CONNELL BEQ.

1958 Evie Hone ST. REMY DE PROVENCE (GLEIZE'S HOUSE)
WATERCOLOUR ON PAPER 38.2 x 51 À.F CONNELL BEQ.

1958 Evie Hone SQUARE, AREZZO GOUACHE ON PAPER 24.5 x 35 A.F CONNELL BEQ.

Mainie Jellett ABSTRACT OIL ON CANVAS 104 x 81.5

RHA (e) Augustus John PORTRAIT OF MRS PAMELA GROVE RED/CHALK/PAPER 41.91 x 32.38 GROVE BEQ.

 Joseph Malachy Kavanagh KILLESHINE PONDS OIL ON BOARD 35.6 x 25.1

 Joseph Malachy Kavanagh WOODLAND PASTURES OIL ON BOARD 35.6 x 25.1

RHA (e) 1961 Gerald Kelly PORTRAIT OF SIR HUGH LANE OIL ON CANVAS 112.3x84.4

 1960 Gladys McCabe THREE OF ONE HEART OIL ON BOARD 24.5 x 21.5 J.EGAN BEQ.

 1958 William Otway McCannell THE THRONE OF THE GODS & THIS STRANGE WORLD
 OIL ON CANVAS 110 x 125

 1988 Daniel MacDonald BOWLING MATCH AT CASTLEMARY, CLOYNE OIL ON CANVAS 102.8 x 130.8

 1954 Daniel Maclise CRUCIFIXION (SKETCH) OIL ON BOARD 18 x 21.5 FNCI GRANT

 1955 Daniel Maclise LEAR AND CORDELIA WATERCOLOUR ON PAPER 52.7 x 70.5 FNCI GRANT

RHA (e) 1956 Daniel Maclise PORTRAIT OF LADY BLESSINGTON PENCIL ON PAPER 24 x 17

 1956 Daniel Maclise STUDY OF A SEATED GENTLEMAN PENCIL ON PAPER 17 x 21 FNCI GRANT

 1956 Daniel Maclise STUDY OF A SEATED GENTLEMAN PENCIL ON PAPER 17.5 x 13.4 FNCI GRANT

 1956 Daniel Maclise STUDY OF A SEATED GENTLEMAN PENCIL ON PAPER 26 x 19.5 FNCI GRANT

 1986 Daniel Maclise THE BUNCH OF GRAPES PENCIL/WASH ON PAPER 20 x 15.5

RHA (e) 1955 Daniel Maclise THE FALCONER OIL ON CANVAS 61 x 47

 Ferenc Martyn ABSTRACT WATERCOLOUR ON PAPER 29.8 x 39.5

RHA (e) 1963 William Mulready LANDSCAPE WITH FARM BUILDINGS OIL ON CANVAS 49 x 66 MRS.A. BODKIN

RHA (e) 1963 William Mulready NUDE STUDY PASTEL ON PAPER 54 x 30 MRS.A. BODKIN

 1979 Patrick O'Sullivan BANNER MARBLE 47.5 x 93 FNCI GRANT

RHA (e) 1958 Henry Marriott Paget PORTRAIT OF JOHN O'LEARY OIL ON CANVAS 60 x 50.5

RHA (e) 1981 Mervyn Peake HEAD OF A GIRL CONTE CRAYON/PAPER 35.5 x 27.5 GROVE BEQ.

 1980 Nano Reid ANSTY PENCIL ON PAPER 43.5 x 34.2 FNCI GRANT

RHA (e) 1981 Thomas Rowlandson WOODS NEAR ALBURY AND TRING, HERTS
 PEN/INK ON PAPER 17.14 x 39.37 GROVE BEQ.

 1961 George Russell PORTRAIT OF RUTH LANE (MRS. SHINE) OIL ON CANVAS 76.2 x 63.6 MRS SHINE BEQ.

 1963 George Sharp OLD MAN PRAYING OIL ON CANVAS 45.5 x 35.5 MRS.A. BODKIN

 Anne Stafford King Harman NEPHIN BEG, CO. MAYO GOUACHE ON PAPER 26.8 x 50

 Anne Stafford King Harman SNOW IN WICKLOW GOUACHE ON PAPER 49 x 34.5

RHA (e) 1988 Paul Signac CONCARNEAU WATERCOLOUR ON PAPER 27.5 x 39.5 M. PURSER

RHA (e) 1973 Jack B.Yeats RETURNING FROM THE BATHE, MID-DAY 1948 OIL ON CANVAS 61.5 x 91.8 FNCI GRANT

Drogheda Municipal Art Collection

1973 Rene Bro A FORMALISED LANDSCAPE OIL 64 x 81

1973 Sylvia Cooke-Collis THE TWELVE PINS WATERCOLOUR 26 x 35.5 COOKE-COLLIS BEQ.

RHA (e) 1963 Beatrice Elvery AFFECTIONATE COUPLE – 1902 PASTEL ON TONED PAP. 34.2 x 30.3 MRS. A BOKIN BEQ.

1969 Jack P. Hanlon THE GOLDEN CAGE OIL ON CANVAS 69 x 49

1960 Evie Hone EVENING, MONTPARNASSE GOUACHE ON PAPER 35 x 23

1959 Evie Hone SEASCAPE OIL ON CANVAS 25 x 40 A.F CONNELL BEQ

1973 Mainie Jellett COAST SCENE WITH PATH GOUACHE 3 x 35 COOKE-COLLIS BEQ.

1968 Dany Lartigue NATURE MORT AUX OEUFS OIL ON CANVAS 64 x 80

RHA (e) 1960 William Leech THE CREEK, TUCKTON OIL ON CANVAS 44 x 35 J.M EGAN BEQ

1972 Ferenc Martin ABSTRACT WATERCOLOUR 30 x 40

1972 Ferenc Martin ABSTRACT 41 x 30

RHA (e) 1963 William Mulready MINIATURE OF ARTIST'S HAND IVORY 6 x 8 MRS A BODKIN .

RHA (e) 1948 Andrew O'Connor DEIRDRE P/CAST OF BRONZE 34 x 23 D.M. FRAZER

1979 Nano Reid LEGENDE OIL ON BOARD 50.8 x 60.9 A. STAFFORD KING HARMAN BEQ

1981 Mervyn Peake HEAD OF A GIRL PASTEL 37 x 28 GROVE BEQ.

RHA (e) 1959 19th Century PORTRAIT OF A LOUTH MILITIAMAN C1810/16 OIL ON CANVAS 56 x 48 FNCI GRANT

Dublin Civic Museum

1984 John Ellis PROPOSED DUBLIN MUSEUM & ART GALL. C1788 PRINT 37.5 x 24.1 C.E.F. TRENCH

1982 Arthur Herbert Orpen POLICE CHARGE STUDENTS AT T.C.D. 1858 PENCIL/INK SKETCH 27.9 x 38.1 C.E.F. TRENCH

Dun Laoghaire-Rathdown County Council

RHA (e) Pierre Bonnard ROOM INTERIOR WATERCOLOUR 7 x 51 RALPH CUSACK

Thurloe Connolly A SHIP OIL 28 x 40 RALPH CUSACK

M. Dixon ELLEN, MY WIFE BRONZE 25CMS. H RALPH CUSACK

Stephen Gilbert FIGURE WATERCOLOUR 40 x 22 RALPH CUSACK

P. Hall ALLEGORY OIL 60 x 19.5 RALPH CUSACK

Grace Henry PORTRAIT OF MRS. MARY DIXON AASWAD OIL 45 x 34 RALPH CUSACK

RHA (e) Nathaniel Hone MALAHIDE FLATS OIL 24 x 32 RALPH CUSACK

Edward Jeffrey Irving PAINTER AND MODEL WATERCOLOUR 16 x 20 RALPH CUSACK

Mainie Jellett ABSTRACT COMPOSITION WASH 51.5 x 27 RALPH CUSACK

Mainie Jellett ABSTRACT COMPOSITION WASH 48 x 42 RALPH CUSACK

Mainie Jellett ABSTRACT COMPOSITION WASH 46 x 21 RALPH CUSACK

Mainie Jellett OAK TREE WASH 30.5 x 23.5 RALPH CUSACK

V. Nichols STILL LIFE OIL 60 x 60 RALPH CUSACK

RHA (e) Eduardo Paolozzi FIGURE WATERCOLOUR 64 x 41 RALPH CUSACK

RHA (e) Basil Rakoczi GROUP OF MEN WATERCOLOUR 24 x 34 RALPH CUSACK

Anthony Redford MAN'S HEAD WATERCOLOUR 36 x 25 RALPH CUSACK

Mary Swanzy PORTRAIT OF JULIET OIL ON PAPER 24 x 21 RALPH CUSACK

Enniscorthy Museum
Sylvia Cooke-Collis INTERIOR OIL ON CANVAS 60 x 49

RHA (e) Erskine Nichol AN OLD FENIAN OIL ON CANVAS 60 x 50 DR & MRS. R.R. WOODS

Fermanagh County Museum, Enniskillen
1983 William Scott "LOUISE" 1939 OIL ON CANVAS 72 x 89 FNCI GRANT

1998 William Scott STILL LIFE-THREE PEARS AND PAN LITHOGRAPH/2 COLOURS 42.9 x 61 FNCI GRANT

Galway Municipal Art Collection
RHA (e) 1995 Clare Sheridan BALCONY OIL ON CANVAS 56 x 46 DR. T. RYAN

Glebe House and Gallery, Donegal
RHA (e) 1996 Derek Hill THE VIOLINIST OIL ON CANVAS 67 x 49 LADY DUNSANY

1988 Bea Orpen LANDSCAPE WITH SHORELINE OF MULRANY GOUACHE 34 x 48 C.E.F TRENCH

Heraldic Museum, Dublin
RHA (e) 1994 Leo Whelan PORTRAIT OF THE O DONOGHUE OF THE GLENS OIL ON CANVAS 50 x 98 FNCI GRANT

1996 PORTRAIT OF EDWARD VII DAGUERREOTYPE 12.5 x 10.0

Hugh Lane Municipal Gallery of Modern Art
18th century COUCH, PROPERTY OF EARL OF CHARLEMONT GILT CARVED WOOD

HLMGMA (e) Joseph Albers HOMAGE TO THE SQUARE - AGLOW OIL ON BOARD 101 x 101 FNCI GRANT

1944 Bernard Albertini FIGURE GROUP OIL ON CANVAS 38.1 x 46.3 SARAH PURSER

C.E.Alexander THE SEVERN ESTUARY WATERCOLOUR 17.7 x 26.6

1930 Louis-R Antral LE CONQUET, FINISTERE OIL ON CANVAS 65.4 x 55.4

Naoum Aronson KIM MARBLE 40.6

Mrs. R. Ashe King PORTRAIT OF R. ASHE KING OIL ON CANVAS 43 x 38.4 MRS. ASHE KING

1944 Stephen Bone BERE ISLAND, CO. CORK OIL ON CANVAS 48.9 x 59.7 GEORGE DARLEY

HLMGMA (e) 1940 Pierre Bonnard BOULEVARD DE CLICHY (C.1911)
OIL ON CANVAS 50 x 69 R.I BEST BEQ.

Pierre Bonnard FLOWERS PRINT 55.9 x 41.9

1970 Paul Bony SAINT JOHN STAINED GLASS 0.4 x 41.9

1949 Francisco Bores STILL LIFE WITH LEMONS OIL ON CANVAS 53.3 x 64.7

1960 H.B.Brabazon TOURNOUS SUR SAOME GOUACHE 24.7 x 33.0 R.I BEST BEQ.

RHA (e)	1960	Gerald Brockhurst GIRL'S HEAD PENCIL ON PAPER 21.9 x 16.5	
		Paul Cezanne APPLES AND ORANGES PRINT 40.0 x 50.2	
		Paul Cezanne BOY SEATED PRINT 78.7 x 63.5	
	1959	Michel Ciry THE VIRGIN OF PITY OIL ON CANVAS 81.2 x 64.7	
	1944	Antoni Clave GIRL WITH COCKEREL OIL ON CANVAS 78.7 x 58.4	
	1962	Louis Coignard LABOURS OIL ON CANVAS 60.3 x 81.2	
	1982	Patrick Collins ISLAND LANDSCAPE OIL ON BOARD 30.4 x 45.7 A. STAFFORD KING HARMAN BEQ.	
RHA (e)	1969	Charles Conder LADIES BY THE SEA PENCIL/CRAYON ON PAPER 10.1 x 13.9 R.I. BEST BEQ	
	1960	Charles Conder NEWQUAY PENCIL/CRAYON ON PAPER 13.9 x 22.2 R.I. BEST BEQ	
RHA (e)		William Conor A SUP OF TEA OIL ON BOARD 59.7 x 49.5	
	1962	Jean Corot REFLETS OIL ON CANVAS 128.2 x 88.9	
RHA (e)	1957	Robertson Craig CONVERSATION PIECE – DR& MRS L ROBINSON OIL ON CANVAS 76.2 x 101.6	
HLMGMA (e)	1946	A. Dunoyer De Segonzac ST. TROPEZ WATERCOLOUR 53.34 x 73.66	
		Raoul Dufy THE CORNFIELD REPRODUCTION 40.0 x 51.4	
		Raoul Dufy LES REGATES A DEAUVILLE COLOURED REPRO. 30.4 x 76.2	
	1939	Philip de Laszlo PORTRAIT OF MRS. DE LASZO OIL ON CANVAS 120.6 x 81.2 MRS. DE LASZLO	
	1959	Jan Elvire ST. ANNE OIL ON CANVAS 81.3 x 64.8	
RHA (e)	1963	Jacob Epstein MAN OF ARAN OR TIGER KING BRONZE 44.4 H	
	1965	Jacob Epstein SIR ALEC MARTIN BRONZE BUST 55.8 H SIR ALEC MARTIN	
	1960	Mrs. Alice Fanner Taite BEACH SCENE OIL ON BOARD 26 x 33.1 R.I. BEST BEQ	
	1935	John B. Flanagan MOTHER AND CHILD LIMESTONE 38.1 MR & MRS C.P. CURRAN	
		Othon Friesz LANDSCAPE PRINT 55.8 x 43.2	
	1938	Elizabeth Frink THE LINK BRONZE	
	1944	Paul Gauguin COLOURED LITHOGRAPH LITHOGRAPH 67.3 x 84.4	
	1988	Wilhelmina Geddes CINDERELLA DRESSING HER UGLY SISTERS WATERCOLOUR 26 x 15.2 SEAN PURSER BEQ.	
HLMGMA (e)	1964	Wilhelmina Geddes SCENES FROM LIFE OF ST.COLMAN MACDUAGH STAINED GLASS PANEL 45.7 x 25.4	
HLMGMA (e)	1964	Wilhelmina Geddes SCENES FROM LIFE OF ST.COLMAN MACDUAGH STAINED GLASS PANEL 45.7 x 25.4	
HLMGMA (e)	1964	Wilhelmina Geddes SCENES FROM LIFE OF ST.COLMAN MACDUAGH STAINED GLASS PANEL 45.7 x 25.4	
	1929	Percy Gethin LANDSCAPE OIL ON CANVAS 28 x 35.5	
	1949	Percy Gethin A TRAVELLING CIRCUS ETCHING 18.4 x 21.9 LORD KILLANIN	
		Percy Gethin THE COLOSSEUM ROME ETCHING 20.9 x 31.1 LORD KILLANIN	
RHA (e)	1960	Beatrice Glenavy THE BIRTH OF VENUS OIL ON CANVAS 35.5 x 25.4 R.I. BEST BEQ	

1931 Duncan Grant SHIPS IN HARBOUR DRAWING - PASTEL 40.6 x 52

1964 Morris Graves SPRING WITH MACHINE AGE NOISE TEMPERA ON PAPER 42.5 x 137.1

1972 Derrick Greaves TWO ROOMS A/C CANVAS 170.1 x 251.4

C.E. Gribben LANDSCAPE OIL ON CANVAS 73.2 x 92.1

1965 Renato Guttuso RED ROOFS OIL ON CANVAS 88.9 x 129.5

1970 Alice B. Hammerschlag FLIGHT 1965 OIL ON CANVAS 114.3 x 114.3

1935 Bernard Harrison JARDIN A LA FRANCAISE OIL ON CANVAS 72.3 x 92.1 B. HARRISON

Daniel Havell A VIEW OF PART OF THE BAY & CITY OF DUBLIN COLOURED ENGRAVING 24.7 x 86.3

1982 William Hayter PAINTING OIL ON CANVAS 45.7 x 64.7 FNCI GRANT

RHA (e) 1972 Michael Healy OUTSIDE THE COURTS, 1932 STAINED GLASS 35.5 x 27.9

1960 Grace Henry HOBBY HORSES OIL ON CANVAS 15.2 x 19.9

RHA (e) 1969 Paul Henry TURF BOG SCENE OIL ON BOARD 20 x 31.1 R.I BEST BEQ

Derek Hill PORTRAIT OF ANDY SHIELDS OIL ON CANVAS 50.8 x 78.7

HLMGMA (e) Ivon Hitchens RINGED LILY OIL ON CANVAS 58.4 x 76.2 LADY MEYER

1973 Evie Hone ABSTRACT GOUACHE 63.8 x 55.2

1982 Evie Hone HEAD OF CHRIST GOUACHE 47 x 34.2

1973 Evie Hone JUGS STAINED GLASS 52.7 x 22.2

1958 Evie Hone THE COCK STAINED GLASS PANEL 45.7 x 17.7

HLMGMA (e) 1961 Evie Hone THE DEPOSITION (c.1953) STAINED GLASS PANEL 36 x 23 J.M. EGAN BEQ.

1973 Evie Hone ST.VINCENT MONOTYPE 31.7 x 21.9

HLMGMA (e) 1963 Horace Hone PORTRAIT OF LORD CHARLEMONT OIL ON PANEL 25.4 x 20.3

1935 Marie Howet LANDSCAPE AT ACHILL GOUACHE 49.5 x 63.5

1936 John Hughes GEORGE RUSSELL "AE" PLASTER 43.2

1929 Selwyn Image STD.GLASS CARTOON

Selwyn Image CHRIST THE KING STND GLASS CARTOON 195.5 x 76.2 MRS.S. IMAGE

1959 Elvire Jan ST. ANNE OIL ON CANVAS 81.2 x 64.7

1945 Mainie Jellett DEPOSITION OIL ON CANVAS 121.2 x 66.9

1973 Mainie Jellett HAND BILL OF MAINIE JELLETT EXHIBITION

1982 Augustus John MAN WITH A MONOCLE OIL ON CANVAS 60.9 x 50.8 GROVE BEQ.

1982 Neville Johnson MIRIAM OIL ON BOARD 63.5 x 51.4 A. STAFFORD KING HARMAN BEQ.

1977 Christo Javacheff WRAPPED WALKWAYS MIXED MEDIA 71 x56 (2) ROSC 1977

RHA (e) 1982 Seán Keating CONRADESQUE OIL ON PANEL 119.3 x 119.3 SIR ALEC MARTIN

RHA ⒠ 1960 Gerald Kelly CONVERSATION PIECE OIL ON CANVAS 38.1 x 48.2 R.I. BEST BEQ

1960 Gerald Kelly GOYESCA III OIL ON CANVAS 81.2 x 55.8 R.I. BEST BEQ

RHA ⒠ 1935 Harry Kernoff WINETAVERN STREET OIL ON PANEL 35.8 x 50.8

1930 Pierre Ernest Kohl SUZANNE AU CANAPE OIL ON CANVAS 59.7 x 81.2 MR. H. JACOB

Oscar Kokoschka LYONS PRINT 43.1 x 55.8

1936 Karoly C. Kotasz LANDSCAPE OIL ON CANVAS 35.8 x 38.4

Dany Lartigue STILL LIFE WITH FLOWERS OIL ON

1970 Le Chevalier THE GOOD SAMARITAN STAINED GLASS 50.8 x 50.8

RHA ⒠ 1960 William Leech THE CIGARETTE OIL ON CANVAS 62.5 x 40.9 R.I. BEST BEQ.

Alphonse Legros STUDY OF TWO HEADS SILVER POINT 24.1 x 29.2

1927 Therese Lessore AT THE PIANO OIL ON CANVAS 50.8 x 60.9

1938 André Lhote LA CUISINE OIL ON CANVAS 60.96 x 12.7

RHA ⒠ 1950 André Lhote LANDSCAPE (c.1930-35) OIL ON CANVAS 60.4 x 73.4

André Lhote THE BASIN OF THE ARCACHON PRINT 45.1 x 56.5

1938 Philip Little DANVERS RIVER ETCHING 20 x 25 MRS. W.R. NOLAN

1938 Philip Little DERBY WHARD NO. 2. ETCHING 23.1 x 20.3 MRS. W.R. NOLAN

1950 Jean Lurcat COQ GUERRIER TAPESTRY 137.1 x 99

1933 Jean Lurcat DECORATIVE LANDSCAPE OIL ON CANVAS 187.9 x 129,5

1972 Ferenc Martyn COMPOSITION GOUACHE 29.2 x 34.2

1936 Franz Masereel ESTAMINET DE MATELOTS OIL ON CANVAS 96.5 x 127

Henri Matisse INTERIOR PRINT 39.6 x 52

Henri Matisse WOMAN SEATED PRINT 54.6 x 36.8

1930 J. McAllister A MOUNTAIN VIEW, OMEATH WATERCOLOUR 26.6 x 36.8

RHA ⒠ 1996 F. E. McWilliam STUDY FOR WOMEN OF BELFAST NO.1 PEN & INK, WASH 29.5 x 42

1927 Bernard Meninsky MOTHER AND CHILD OIL ON CANVAS 83.8 x 74.9

RHA ⒠ 1956 Henry Moore RECLINING FIGURE BRONZE 96.5 L

HLMGMA ⒠ 1944 Berthe Morisot THE SAIL BOAT W/COLOUR 24.1 x 19.7

1931 John Nash AUTUMN BERRIES OIL ON CANVAS 50.8 x 76.2

1989 Paul Neagu CATALYTIC STATIONS MIXED MEDIA 71.1 x 106.7

C.R.W. Nevinson QUAI HENRY IV FROM QUAI DES GRANDES AUGUSTINS
OIL ON CANVAS 45.7 x 60.9 MR. H. JACOB

Bertram Nicholls PIAZZA DEL DUOMO, ORVIETO OIL ON CANVAS 40.6 x 48.2 MR. H. JACOB

RHA ⒠ 1984 Sir Sidney Robert Nolan NED KELLY AT THE RIVER (1964) OIL ON BOARD 150.4 x 120

1976 Leopoldo Novoa RELIEF PAINTING MIXED MEDIA 137.1 x 190.8

1953 Daniel O'Neill ST. JOSEPH'S CHURCH, RATHMULLAN OIL ON PANEL 43.2 x 48.2

1952 Sir William Orpen PORTRAIT OF REV. J.W. LANE M.A. OIL ON CANVAS 91.4 x 81.3

1939 Pissarro Orovida FLORA AND FAUNA TEMPERA 60.3 x 47 MISS J. CUNNINGHAM

RHA ⓔ Walter Osborne THE RISING MOON, GALWAY BAY OIL ON BOARD 31 x 39.5

Sean O'Sullivan PORTRAIT OF GEORGE RUSSELL (AE) DRAWING 31.7 x 41.9

Ann St. John Partridge LA PLACE MONTREUIL SUR MER OIL ON MILLBOARD 49.5 x 59.7

R.M. Pearsall RUE DE BEARBRIDES, MALINES ETCHING 55.9 x 40.6 MRS. GEOGHEGAN & SARAH PURSER

R.M. Pearsall STORM OVER A VILLA ETCHING 33 x 51 MRS. GEOGHEGAN & SARAH PURSER

Pablo Picasso LES ORCHIDEES OIL ON CARDBOARD 25.4 x 21.6

Pablo Picasso STUDY OF A WOMAN LITHOGRAPH 30.5 x 25.4

Pablo Picasso WOMAN IN WHITE PRINT 47 x 38.1

1953 John Piper CAVESBY CROSS WITH HOLLYHOCKS GOUACHE ON CARDBOARD 68.6 x 53.3

Albert Power BLESSED OLIVER PLUNKETT MARBLE 72.4

RHA ⓔ 1944 Sarah Purser MAUD GONNE OIL ON CANVAS 176.5 x 105.7

Sarah Purser MAUD GONNE PASTEL ON PAPER 43 x 27

1963 Sarah Purser PAINTING OF A WOMAN CR.ON PPR.MNTD.CAN. 91.4 x 63.5

1944 Sarah Purser PORTRAIT OF W. B. YEATS PASTEL 43.2 x 26

Ernest Quost FLOWERS OIL ON CANVAS 76.2 x 55.9

1959 Paul Rebeyrolle STILL LIFE WITH FISH OIL ON PANEL 31.1 x 117.5

RHA ⓔ 1957 Nano Reid CATS IN THE KITCHEN OIL ON PANEL 39.3 x 58.4

1982 Nano Reid RUBBISH DUMP OIL ON BOARD 45.7 x 60.9 KIRKPATRICK BEQ.

1982 Nano Reid WOODS AT ARDNACASHEL OIL ON BOARD 29.8 x 38.1 A. STAFFORD KING HARMAN BEQ

RHA ⓔ 1970 Maurice Rocher THE SCOURGING STAINED GLASS 38.1 x 27.9

HLMGMA ⓔ Georges Rouault CHRIST AND THE SOLDIER (1930)
MIXED MEDIA ON BOARD 63.5 x 48.2

Georges Rouault STUDY OF A WOMAN PRINT 30.5 x 17.8

Georges Rouault THE OLD KING PRINT 57.1 x 40

Pierre Rousseau MAURESQUE COUCHEE OIL ON CANVAS 45.7 x 60.9

RHA ⓔ 1956 Augustus Saint-Gaudens PORTRAIT OF ROBERT LOUIS STEPHENSON BRONZE 44.4 DIAM.

Jacinto Salvado LE PEINTRE ET SES MODELES OIL ON CANVAS 129.5 x 96.5

1959 Anne Saporetti AN ARRANGEMENT WITH ARCHITECTURE GOUACHE ON CARDBOARD 21.6 x 38.1

Lucien Simon ST. ETIENNE DU MONT OIL ON CANVAS 68.6 x 91.4

1944 Fean Souverbie COMPOSITION FIGURES AND HORSE OIL ON CANVAS 91.4 x 63.5 M. SWANZY BEQ.

 Andre Strauss AUVERGNE LANDSCAPE OIL ON CANVAS 58.4 x 58.4 MRS. E. MAUNSELL

1929 Mary Swanzy BUTCHER'S BROOM OIL ON

 Mary Swanzy LANDSCAPE OIL ON PANEL 51.4 x 61.6

1982 Mary Swanzy LANDSCAPE WITH RED GABLE OIL ON CANVAS 45.7 x 53.3

RHA (e) 1944 Mary Swanzy PORTRAIT OF SARAH PURSER OIL ON CANVAS 58.5 x 49.5

RHA (e) 1992 Mary Swanzy SARAH PURSER AT DOORWAY OF MESPIL HOUSE OIL ON CANVAS 51 x 41

RHA (e) Patrick Tuohy PORTRAIT OF SEAN O'CASEY PENCIL DRAWING 42.5 x 35.5

1968 Gunther Uecker GROSSE SPIRALE NAILS ON BOARD 149.8 x 149.8

HLMGMA (e) Maurice Utrillo LA RUE MARCADET OIL ON PANEL 55.2 x 76.8

 Maurice Utrillo THE ROAD MONT CENIS PRINT 44.4 x 55.2

1938 Maurice de Vlaminck THUNDERSTORM PRINT 44.4 x 56.5

HLMGMA (e) 1944 Maurice de Vlaminck OPIUM OIL ON CANVAS 81.3 x 53.6 MEM. SARAH PURSER

1960 S. Watson STUDY EN GOUACHE GOUACHE 29.8 x 33.6 DR.R.I BEST BEQ

1954 Fritz Winter COMPOSITION COL. LITHOGRAPH 53.3 x 71.1

HLMGMA (e) 1973 Jack B. Yeats THE BALL ALLEY (c.1927) OIL ON CANVAS 45.7 x 60.9 MRS.E. CASE BEQ

Irish Architectectural Archive

1992 Patrick Abercrombie THE CIVIC SURVEY DUBLIN & ENVIRONS 1925 2 SETS - C.I.I. MAPS LADY DUNSANY

1982 John Bowden DESIGN FOR A VILLA FOR ARTHUR CRAWFORD
INK & COLOURED WASH 18.5 x 48.75 FNCI GRANT

1986 Richard Castle 20 CHARLEVILLE CASTLE DRAWINGS INK VARIOUS DR.T.GRANT

1981 Lord Gerald Fitzgerald DESIGN FOR THE ORGAN IN SALOON AT CARTON
INK ON TRACING PAPER 51 x 39.5 FNCI GRANT

1981 Henry Hill HOUSE DESIGN MONKSTOWN, CO. CORK FRAMED WASH PERSPECT 48 x 61.9 FNCI GRANT

1979 Raymond McGrath ARCHITECTURAL DRAWINGS FOR "THE BELL" PAPER FNCI GRANT

1992 DR. CLARKE'S FREE SCH DROGHEDA SITE INK 32.3 x 40.1 DR.T.GRANT

1992 DR. CLARKE'S FREE SCH DROGHEDA INK & WASH 50.7 x 35.6 DR.T.GRANT

1992 DR. CLARKE'S FREE SCH DROGHEDA INK & WASH 29.3 x 44.9 DR.T.GRANT

1992 DR. CLARKE'S FREE SCH DROGHEDA INK 32 x 19.9 DR.T.GRANT

1995 MODEL OF DROMORE CASTLE, CO. KERRY WOOD FNCI GRANT

1992 2 MAPS THE CIVIC SURVEY OF DUBLIN 1925 PRINTED SHEETS 56.5 x 42.3 LADY DUNSANY

Irish Countrywoman's Association

1958 Evie Hone TREES AT MARLAY GOUACHE A.F. CONNELL BEQ

 COLLECTION OF LACE

Irish Museum of Modern Art, Kilmainham

1986 Clifford Rainey NO STOMACH FOR THE BATTLE OF LOVE & HATE
675 x 530 THE HON. JUSTICE BRIAN WALSH

RHA ⓔ 1998 Patrick Swift SELF-PORTRAIT IN THE STUDIO, c 1959 OIL ON CANVAS 122 x 76

Kerry County Library

RHA ⓔ 1966 William Henry Bartlett A VIEW OF BALLYBUNION INK, WASH DRAWING 15 x 20 FNCI GRANT

1985 Anne Herbert Sealy BLENNERVILLE, TRALEE (DATED 1870) OIL ON CANVAS 91 x 82.5 FNCI GRANT

RHA ⓔ 1996 Cornelius Varley LIXNAW CASTLE AT EVENING WATERCOLOUR 27.9 x 38.1 FNCI GRANT

Kilkenny Archaeological Society

1999 George Holmes A VIEW OF KILKENNY FROM THE RIVER NORE WATERCOLOUR 38.1 x 53.3 GRANT

Killarney Branch Library

1981 Publ. by Newman & Co THE EAGLE ROCK, KILLARNEY LITHOGRAPH 355.6 x 254

1981 Publ. by Newman & Co LOWER LAKE FROM LAKE HOTEL, KILLARNEY
LITHOGRAPH C1850-70 254 x 355.6 FNCI GRANT

1981 Publ. by Newman & Co OLD WEIR BRIDGE, KILLARNEY LITHOGRAPH 254 x 355.6 FNCI GRANT

1973 Cornelius Varley HAGGARDS DOORWAY, AGHADOE OIL COL/PAPER/BL.LD. 284 x 451 FNCI GRANT

1981 W. L. Walton MONASTERY ON INNISHFALLON IS.& ROSS LITHOGRAPH 254 x 355.6 FNCI GRANT

1981 THE UPPER LAKE KILLARNEY FROM KENMARE 254 x 355.6 FNCI GRANT

Kinsale Museum

1980 William Wall QUEEN ANNE CIRCULAR PUNCH BOWL C 1712 SILVER 27.5CM DIAM. FNCI GRANT

1974 VIEW OF KINSALE HARBOUR AND CHARLES FORT RESTORATION GRANT

Limerick City Gallery of Art

1948 Kathleen Clausen O'Brien SNOWDEN OIL ON LINEN 61 x 91.5

1973 Sylvia Cooke-Collis HERBACEOUS FLOWERS TEMPERA ON PAPER 28.5 x 23

1948 J. C. Dollman VIEW OF SUSSEX DOWNS WATERCOLOUR ON PAPER 37 x 52.5

RHA ⓔ Henri Hayden LE PORT OIL ON LINEN 60 x 81

1958 Evie Hone A WALK IN THE WOODS AT MARLAY OIL ON BOARD 41 x 46

1973 Evie Hone LANDSCAPE WITH BRIDGE WATERCOLOUR ON PAPER 29 x 40.5

1973 Mainie Jellett PIETA ABSTRACT (1946) WATERCOLOUR ON PAPER 19 x 48.5

1973 Ferenc Martyn ABSTRACT WATERCOLOUR ON PAPER 30 x 40

1982 David Nash 3 SMALL WOODEN RUNNING TABLES WOOD (SCULPTURE) 30 x 23 FNCI GRANT

1982 Mervyn Peake GIRL UNDRESSING INK DRAWING 36.83 x 25.4 GROVE BEQ.

1981 Mervyn Peake THE ARROGANT HORSE INK DRAWING 36.83 x 26.67 GROVE BEQ.

1979 Mary Swanzy FROM THE SEA OIL ON LINEN 44.5 x 52 DR. E. FITZPATRICK

1973 Abel Vallmitjana SAN FRANCESCO OIL ON LINEN 101 x 60.5

Limerick Museum
1993 Henry Stirling Limerick longcase wallclock GRANT

Listowel Branch Library
1973 Cornelius Varley LIXNAW, CO. KERRY BLACK LEAD 120 x 383 FNCI GRANT

1973 Cornelius Varley REMAINS OF KERRY HOUSE AT LIXNAW, KERRY BLACK LEAD 192 x 495 FNCI GRANT

Malahide Castle
1976 Hanbury HALL LANTERN BRASS

RHA (e) 1992 Unknown PORTRAIT OF LORD KILWARDEN ENGRAVING 40.64 x 34.29 MISS R. MILLS

RHA (e) 1975 Unknown WALL SCONCES PINE WOOD & GILDED 86.36 x 45.72 FNCI GRANT

1975 Unknown 2 GEORGIAN IRISH SIDE TABLES PINE WOOD & GILDED 800 x 980 FNCI GRANT

1975 Unknown MIRROR PINE WOOD & GILDED 102 x 67 FNCI GRANT

1975 Unknown SIDE TABLE PINE WOOD & GILDED 37 x 79 FNCI GRANT

RHA (e) 1992 LORD KILWARDEN'S WRITING DESK + DOCS. MIXED 16.51 x 26.67 MISS R. MILLS

Mansion House
1988 2 HICKS SIDE-TABLES MILLENIUM GIFT

Archbishop Marsh's Library, Dublin
1992 2 SHOW CASES

1998 An Biobla Naofa BOUND VOLUME Ms. Jane Williams

Millmount Museum
1981 Bea Orpen MCCANN AND HILL'S GRAIN LOFTS GOUACHE ON PAPER 20 x 26 MR. C.E.F. TRENCH

Monaghan County Museum
1997 Ambrose McEvoy STANDING NUDE OIL ON CANVAS 75 x 62 LADY DUNSANY

1980 John Nixon CASTLEBLAYNEY WATERCOLOUR

RHA (e) 1981 Bea Orpen CUTTING TURF, ANNAGHMAKERRIG GOUACHE 22.2 x 33.7 C.E.F. TENCH

1981 Mervyn Peake HEAD OF A GIRL CHARCOAL 56.2 x 43.9 GROVE BEQ.

1988 Captain Walter Synot CASTLEBLAYNEY FROM THE NEWRY ROAD WATERCOLOUR 30 x 20

RHA (e) 1981 VOLUNTEER UNIFORM OF 1782 FNCI GRANT

1983 Alexander Williams LION ROCKS, HOWTH WATERCOLOUR SKETCH 39 x 62

RHA (e) 1987 18TH CENTURY FARNEY YEOMANRY COLOUR SILK 170 x 170 RESTORATION GRANT

Muckross House, Killarney
1979 George Mirianon LES RUINES OIL ON CANVAS 45 x 37.5 MRS. D. PLAISTOWE BEQ

1979 Ernest Roth ANCHORAGE, CAMOGLI 1931 ETCHING 35 x 25 MRS. D. PLAISTOWE BEQ

National Gallery of Ireland
HLMGMA (e) 1963 George Barret A STORMY LANDSCAPE (c. 1760) OIL ON CANVAS 55 x 60 MRS. A. BODKIN

1956 Jeremiah Barrett PORTRAIT OF MASTER D. DALY (1765) OIL ON CANVAS 76 x 64

1959 James Barry THE DEATH OF ADONIS (c. 1775) OIL ON CANVAS 100 x 126 MR. & MRS. FIELD

1963 James Barry JACOMO AND IMOGEN (CYMBELINE) (c.1790) OIL ON BOARD 48 x 61 MRS. A. BODKIN

1947 Bassano, School of THE PROCESSION TO CALVARY OIL ON CANVAS 100 x 131 SIR ALEC AND LADY MARTIN

RHA ⓒ 1959 Max Beerbohm PORTRAIT OF W.B. YEATS (c.1895) INK AND WATERCOLOUR ON PAPER 32 x 18.7

1985 Nathaniel Bermingham PROFILE PORTRAIT OF A YOUNG BOY PASTEL ON PAPER 25.3 x 20.1 MR. M. RUSSELL

1997 Alicia Boyle GARDEN ROCKFACE (1984) OIL ON CANVAS 71 x 91.5 ALICIA BOYLE BEQ

1997 Alicia Boyle MIDWINTER FORT, ROSSNACAHERAGH (1976) OIL ON CANVAS 71 x 91.5 ALICIA BOYLE BEQ.

1997 Alicia Boyle SEA SLATE (1966) OIL ON CANVAS 76 x 102 ALICIA BOYLE BEQ.

1997 Alicia Boyle SWEENY IN SUMMER (1978) OIL ON CANVAS 76 x 102 ALICIA BOYLE BEQ

1997 Alicia Boyle SWEENY IN WINTER (1979) OIL ON CANVAS 76 x 102 ALICIA BOYLE BEQ

1997 Alicia Boyle WINTER PLANES (1960) OIL ON CANVAS 91.5 x 71 ALICIA BOYLE BEQ

1997 Alicia Boyle 125 SKETCHBOOKS (1931-96) ALICIA BOYLE BEQ.

1947 George Boyle LANDSCAPE (1888) OIL ON CANVAS 25 x 35 MR. G. BOYLE

1928 Louise Breslau PORTRAIT OF BERLIGOT IBSEN (1889) OIL ON CANVAS 131 x 90 MLLE. ZILLHARDT

1955 George Chinnery (attrib) CATTLE UNDER A THATCHED SHELTER PENCIL ON PAPER 15.6 x 16.6

RHA ⓒ John Comerford PORTRAIT OF MRS COOTE (1804) W/C MINIATURE 6.9 x 5.8 MR. L O' CALLAGHAN

RHA ⓒ 1938 Francesco Cuairan TWO SEALS (1934) SCULPTURE IN BASALT 35 x 68 x 25

HLMGMA ⓒ Charles Daubigny LANDSCAPE OIL ON PANEL 18.5 x 33.8 MR. H.J.P. BOMFORD

RHA ⓒ 1974 English School 19c PORTRAIT OF A LADY IN A WHITE DRESS WATERCOLOUR MINATURE 4.5 x 3.8

RHA ⓒ 1974 English School 19c PORTRAIT OF A BOY IN A WHITE SHIRT ENAMEL MINATURE 5 x 4.5

HLMGMA ⓒ 1930 Thomas Frye PORTRAIT OF SUSANAH WALKER (1760) OIL ON CANVAS 99 x 71 SIR ALEC MARTIN

RHA ⓒ 1943 Pieter de Gree BACCHANAL WITH PUTTI (c.1785) OIL ON CANVAS 112 x 142 MR.H. JACOBS

1956 Hugh Douglas Hamilton CUPID AND PSYCHE IN THE NUPTIAL BOWER (1793) OIL ON CANVAS 198 x 151

RHA ⓒ 1974 Richard Hand HALT AT AN INN (1785) STAINED GLASS 26.5 x 31

HLMGMA ⓒ 1959 Thomas Hickey AN INDIAN LADY, PERHAPS JEMDANEE (1787) OIL ON CANVAS 102 x 127 SIR ALEC MARTIN

1953 Frances Hodgkins BOATS ON A RIVER WATERCOLOUR ON PAPER 24 x 29 MRS. S. LYND

1999 George Holmes SWORDS CASTLE (?1790s) WATERCOLOUR ON PAPER 32 x 42.5 MR. M. RUSSELL

1999 George Holmes SWORDS CASTLE ENGRAVING (PHOTOCOPY) 10 x 15 MR. M. RUSSELL

1956 Evie Hone CHRIST AND APOSTLES (c.1947-48) GOUACHE ON PAPER 276 x 71.8

1956 Evie Hone HEADS OF TWO APOSTLES (c.1952) STAINED GLASS 86 x 61 MRS. N. CONNELL

1957 Evie Hone SNOW AT MARLAY (c.1947) OIL ON BOARD 37 x 49

1958 Evie Hone THE CRUCIFIXION AND LAST SUPPER (1950) WATERCOLOUR ON PAPER 123 x 89 MRS. N. CONNELL BEQ

1956 Evie Hone THE VIRGIN AND APOSTLES (c.1947-48) GOUACHE ON PAPER 276 x 71.8

HLMGMA ⓒ 1938 Nathaniel Hone SELF-PORTRAIT (1750s) OIL ON CANVAS 76 x 63 SIR ALEC MARTIN

	1928	Robert Hunter	PORTRAIT OF FRANCIS HUTCHESON OIL ON CANVAS 76 x 63 SIR ALEC AND LADY MARTIN
RHA ⓔ	1973	Irish School 18c	PORTRAIT OF DEAN JONATHAN SWIFT OIL ON CANVAS 76 x 64
RHA ⓔ	1974	Thomas Jervais	PASTORAL LANDSCAPE STAINED GLASS 28 x 20
RHA ⓔ	1974	Thomas Jervais	VIEW OF AN ESTUARY BY MOONLIGHT (c.1785) STAINED GLASS 20.3 x 28
	1982	Augustus John	PORTRAIT OF MRS PAMELA GROVE (1943/45) OIL ON CANVAS 92 x 75 MRS. P. GROVE BEQ
	1952	Seán Keating	AN ALLEGORY (1925) OIL ON CANVAS 102 x 130 SIR ALEC MARTIN

RHA ⓔ 1947 William Turner de Lond THE GRAND ENTRY OF GEORGE IV INTO DUBLIN, 17TH AUGUST 1821
OIL ON CANVAS 171 x 279

1979 Jean Lurçat LUNAR LANDSCAPE GOUACHE ON BOARD 17.5 x 30.5 A. STAFFORD KING HARMAN BEQ

1995 Clare Marsh FLOWER ARRANGEMENT OIL ON CANVAS 26.5 x 34 MISS M. TULLO

1995 Clare Marsh HEAD OF OLD MAN OIL ON CANVAS 33 x 29 MISS M. TULLO

1995 Clare Marsh LANDSCAPE WATERCOLOUR ON PAPER 14.5 x 18 MISS M. TULLO

1995 Clare Marsh PANSY IN A YELLOW JUG WATERCOLOUR ON PAPER 25 x 23 MISS M. TULLO

1995 Clare Marsh PORTRAIT OF GIRL IN A PINK BLOUSE OIL ON CANVAS 47 x 35 MISS M. TULLO

1995 Clare Marsh PORTRAIT OF A SMALL BOY WITH JUG EARS OIL ON CANVAS 45.5 x 32 MISS M. TULLO

1995 Clare Marsh PORTRAIT OF A YOUNG MAN OIL ON CANVAS 45.5 x 35.5 MISS M. TULLO

1995 Clare Marsh SEATED FIGURE, A LANE WITH A RED HOUSE OIL ON CANVAS 49 x 35.5 MISS M. TULLO

1994 Clare Marsh SELF-PORTRAIT (c.1900) OIL ON CANVAS 40 x 28.5 MISS M. TULLO

RHA ⓔ 1994 Clare Marsh SKETCHBOOK 9 X 13 MISS. M. TULLO

1938 Henri Matisse DANCER REFLECTED IN THE MIRROR (1940) LITHOGRAPH ON PAPER 32 x 40

RHA ⓔ 1963 William Mulready A SEATED MALE NUDE (1860) CHALKS ON PAPER 55.4 x 37.8 MRS. A. BODKIN

1934 William Mulready PORTRAIT OF A YOUNG LADY READING A BOOK (1824)
PENCIL ON PAPER 19.2 x 12.3 DR. T. BODKIN

RHA ⓔ 1954 George Mulvany PORTRAIT OF THOMAS F. MEAGHER OIL ON CANVAS 76 x 63

1952 Sir William Orpen TREES AT HOWTH (1910) OIL ON CANVAS 91 x 87 SIR ALEC MARTIN

1939 Walter Osborne A SEATED MAN (c.1882) PENCIL ON PAPER 6.5 x 5 MISS J. FRENCH

1939 Walter Osborne A WOMAN SEWING (c.1882) PENCIL ON PAPER 8.2 X 6.5 MISS J. FRENCH

RHA ⓔ 1939 Walter Osborne SEATED CHILD, WOMAN WITH BASKET, LABOURER
PENCIL ON PAPER 6.5 X 8.5 MISS J. FRENCH

1925 Giuseppe Passeri ? SILENUS AND KING MIDAS INK AND WASH ON PAPER 23 x 55.5 HON. MRS PHILLIMORE

HLMGMA ⓔ 1930 Sarah Purser PORTRAIT OF ROGER CASEMENT (1927) OIL ON CANVAS 102 x 76 MR. W.A. CADBURY

RHA ⓔ 1976 Sarah Purser THE SAD HEAD, KATHLEEN BEHAN (1923) OIL ON BOARD 26 x 24

1970 Richard Rothwell PORTRAIT OF CAPTAIN PATRICK REDMOND OIL ON CANVAS 77 x 64.5

RHA ⓔ 1973 George Russell (AE) SAIDBH TRINSEACH OIL ON CANVAS 61 x 76

1938 Emily Sargent THE WAILING WALL, JERUSALEM WATERCOLOUR ON PAPER 35.8 x 47.1 MME. ARMAND

1979 Gino Severini THREE MUSICIANS (1915/20) INK ON PAPER 24 x 30.5 MISS A. STAFFORD KING HARMAN BEQ

1956 Francesco Simonini CAVALRY FIGHTING BELOW A WALLED TOWN INK ON PAPER 27.5 x 42.5

1970 Thomas Stagg DUBLIN BAY FROM UNIVERSITY ROWING CLUB OIL ON CANVAS 61 x 91

HLMGMA ⓔ 1936 Henry Tonks LA TOILETTE (1936) OIL ON CANVAS 83 x 65

1934 Roelof van Vries LANDSCAPE WITH FIGURES (?1651) OIL ON PANEL 61 x 84

1948 Edouard Vuillard THE HESSEL APARTMENT, RUE DE RIVOLI, PARIS (1903)
PEINTURE Á LA COLLE ON CARD 41 x 53.9

1936 Jacob De Wit AN ALLEGORY OF WINTER INK AND WASHES ON PAPER 21.5 x 15.5 MRS. PERRY

HLMGMA ⓔ 1975 John Michael Wright PORTRAITS OF LADY CATHERINE & LADY CHARLOTTE TALBOT (1679)
OIL ON CANVAS 131.1 x 110.5 FNCI GRANT

1995 Anne Yeats GREEN CLOTH FLOATING (1993) OIL ON PAPER 38 x 57

1960 Jack B. Yeats BEFORE THE START (1915) OIL ON CANVAS 46 x 61 MR J. EGAN BEQ

1960 Jack B. Yeats MANY FERRIES (1948) OIL ON CANVAS 51 x 69 MR J. EGAN BEQ

1949 John Butler Yeats PORTRAIT OF MRS. JOHN BUTLER YEATS (c.1875) OIL ON CANVAS 71 x 61 MISS LILY YEATS

1949 John Butler Yeats PORTRAIT OF SUSAN MARY 'LILY YEATS' (1901) OIL ON CANVAS 91 x 71 MISS LILY YEATS

1956 John Butler Yeats PORTRAIT OF LADY GREGORY (1903) OIL ON CANVAS .62 x 52

1956 John Butler Yeats PORTRAIT OF J.M.KERRIGAN (1911) PENCIL ON CARD 27.3 x 33.1

National Library of Ireland

RHA ⓔ 1929 East Anglian THE BROMHOLM PSALTER RED CALF, QUARTER BOUND 41.8 x 28.6 THE MARQUESS OF LANSDOWNE

RHA ⓔ 1929 East Anglian THE ORMESBY PSALTER RED CALF, QUARTER BOUND 41.8 x 28.6 THE MARQUESS OF LANSDOWNE

RHA ⓔ 1940 Michael Stapleton 200 ARCHITECTURAL DRAWINGS C.P. CURRAN

1940 John Butler Yeats PORTRAIT OF MISS ELIZABETH YEATS PENCIL DRAWING 24.13 x 8.54 JACK B. YEATS

RHA ⓔ 1954 Unknown (Dublin 1738) PLATONIS SEPTEM SELECTI DIALOGI
RED MOROCCO, ORNAMENT 20.32 x 12.7 FNCI GRANT

1972 INCUNABULA FROM KINGS INNS LIBRARY

RHA ⓔ 1932 RELICS OF THOMAS MOORE 2 BROWN BUCKRAM VOLUMES 34.6 x 24.7

National Museum of Ireland

RHA ⓔ 1928 Ethel Ball MODEL OF AN IRISH ELK BRONZE 58 x 56

RHA ⓔ 1926 Horace Hone 1755-1825 MINIATURE OF A DRUID ENAMEL 15.24 x 10.16

RHA ⓔ 1935 Donnchadh O Laoghaire SET OF UILLEAN PIPES 123H FNCI GRANT

1932 Selwyn Image 2 CARTOONS FOR STAINED GLASS MRS. S. IMAGE

1927 English 17/18TH C. EMBROIDERED SILK COVERLET

1927 French 14TH C. DIPTYCH-LEAF/LIFE OF MARY OF EGYPT SCULPTURED IVORY 7.62 x 4.45 MR. H. SINCLAIR

Irish 2 BASKETS, A STRADDLE, TURF BARROW & SLANE DR. T. COSTELLO

Irish EIGHT DIES OF BADGES, SEALS ETC., STEEL & BRASS DR. T. COSTELLO

1938 Lucca 12TH-13TH C. FRAGMENT OF RARE TEXTILE

Unknown (Dublin 17c) A RED POTTERY JUG 24.13 x 20.32

RHA ⓔ 1927 Unknown (English c.1850) HANDKERCHIEF PRINTED - ALL NATIONS FLAGS WHITE SILK 71.12 x 86.36

RHA ⓔ 1928 Unknown (French c.1800) TWO ALTAR CRUETS SILVER 15.24 x 6.03 MR. H. JACOB

RHA ⓔ 1928 Unknown (German 1597) A POWDER HORN - ENGRAVED & DATED 1597 IVORY (INCISED) 25.4 x 8.89 x 4

RHA ⓔ 1936 Unknown (Greek c.1650) PANEL EMBROIDERED/CRUCIFIXION & ENTOMBMENT
IVORY SATIN 35.56 x 27.94 MR. W. BROOKS

A COLLECTION OF CHINA MR. G. DARLEY

RHA ⓔ 1973 A PERUVIAN STIRRUP CUP 16.5H AMERICAN AMBASSADOR

RHA ⓔ 1995 BOG OAK NECKLACE SET (19TH CENTURY) BOG OAK

1927 COLLECTION OF JAVANESE BATIK MR. D. SANTRY

DINNER PLATE TIN-GLAZED POTTERY 30.48 DIAM.

RHA ⓔ 1981 KILLARNEY TABLE ARBUTUS WOOD DIA 170 HT69 FNCI GRANT

RHA ⓔ 1989 MOULDED & PIERCED DISH (DELAMAIN) DELFT BLACK & WHITE 26W

MUG, BRISTOL c.1750 TIN-GLAZED POTTERY 6.35

1982 ONE KOREAN (?) 18TH C. CHARGER PORCELAIN 46.5 DIAM. COUNTESS OF ROSSE

OVAL DISH, SPODE OPAQUE CHINA

PAIR OF PLATE, BRISTOL C.1750 TIN-GLAZED POTTERY 22.35

PLATE C.1790 PORCELAIN, WORCESTER 21.59 DIAM.

17TH C. TOKEN OF CHRIS CUSACK, KILDARE MR. L. FLETCHER

TOKEN OF MATTHEW LONG OF TULLOW PHELIM METAL 1.52

1932 TWO PIECES OF OLD DUBLIN BLUE & WHITE DELFT

1982 TWO 18TH C. FANS COUNTESS OF ROSSE MEM M. ROSSE

UNIFORM OF THE '82 CLUB+5 MEM. CARDS & REC.

Old Dublin Society
1970 Jack P. Hanlon FLOWER STUDY WATERCOLOUR J. HANLON BEQ.

1973 John King SUNDIAL (DATED 1748)

RHA ⓔ John van Nost (Younger) EQUESTRIAN STATUE OF GEORGE II - MAQUETTE
GOLD PAINTED LEAD 61H x 48.25L

Royal Hibernian Academy
1939 Nicholas Crowley A GIRL IN A BLUE DRESS OIL ON PAPER 38.1 x 27.94 MR. T. DAGGAUD

Royal Irish Academy
RHA ⓔ 1985 Mia Cranwill SENATE CASKET COPPER, SILVER, GOLD, ENAM L26 x W13.5H23 REPAIRS GRANT

Royal Society Antiquaries of Ireland
 THE UNIVERSIAL ADVERTISER 18TH C. PUBLICATION MR. B. FITZGERALD

The Niland Gallery Sligo
 Louis L. Boilly COPY OF A CEILING PAINTING BY VERONESE OIL ON CANVAS 66 x 41.9

 Clara Christian LANDSCAPE OIL ON CANVAS 61.6 x 74.9

1969 Clara Christian THE CHERRY TREE OIL ON CANVAS 48.9 x 67.3

1963 Mary Duncan STEPHEN & MARIE MACKENNA AT SEAVIEW TCE. OIL ON CANVAS 66 x 55 MRS. A. BODKIN

1969 May Guinness SEASCAPE (CORFU) PASTEL 25.4 x 19.1

RHA (e) Jack P. Hanlon VASE OF FLOWERS WATERCOLOUR 76.2 x 54.6

 Eva H. Hamilton AT THE FOOT OF THE COLUMN OIL ON CANVAS 26.7 x 34.3

1969 Fairlie Harmon PORTRAIT OF A WOMAN OIL ON BOARD 36.8 x 27.4

1965 Evie Hone DOMINICAN SAINT MONOTYPE 75.6 x 34.3

RHA (e) 1981 Augustus John PORTRAIT OF MAJOR GROVE OIL ON CANVAS 57.1 x 44.4 GROVE BEQ.

1969 Charles Lamb A ROUGH SEA OIL ON CANVAS 29.2 x 38.1

RHA (e) 1961 William Leech NO. 3 PARNELL SQUARE OIL ON BOARD 35.6 x 42.4

1963 R. Mannix THE BASKET WEAVERS OIL ON CANVAS 57.5 x 72.5

RHA (e) 1961 James McNeill Whistler SHOP OWNER SERVING HER CUSTOMERS PENCIL DRAWING 21.6 x 19.1

1969 David Muirhead LANDSCAPE OIL ON BOARD 25.4 x 33

1961 Dermod O'Brien LANDSCAPE OIL ON BOARD 24.1 x 34.3

1963 William Orpen A DUBLIN MODEL PENCIL ON PAPER 11.5 x 15.5 MRS. A. BODKIN

1963 William Orpen PORTRAIT OF MICHAEL DAVITT OIL ON BOARD 25.5 x 24 MRS. A. BODKIN

1963 Albert Power HEAD OF JAMES STEPHENS PLASTER 39CMS HIGH MRS. A. BODKIN

 Saidbh Trinseach PORTRAIT OF SUSAN MITCHELL MR. D. COFFEY

1963 Estella Solomons PORTRAIT OF THOMAS BODKIN OIL ON CANVAS 88.5 x 69.5 MRS. A. BODKIN

1961 Mary Swanzy ABSTRACT OIL ON BOARD 45.7 x 36.8

1961 Crampton Walker A SUSSEX FARM OIL ON BOARD 24.1 x 34.3

1961 Crampton Walker A SUSSEX FARM OIL ON CANVAS 63.5 x 47

 Anne Yeats FACE IN DISTRESS INK 42.5 x 31.7 MR. E. MCDOWELL

RHA (e) 1965 Jack B. Yeats THE SEA AND THE LIGHTHOUSE OIL ON CANVAS 35.5 x 53.5

1963 John B. Yeats PORTRAIT OF ANTONIO MANCINI PENCIL ON PAPER 16 x 10 MRS. A. BODKIN

St. Columb's Donegal
1987 Mainie Jellett THE FAMILY AT KILLYBEGS PEN/INK SKETCH 38 x 56 COUNTESS OF IVEAGH

St. Patricks College, Maynooth
RHA (e) 1996 Frederich Herkner MOTHER AND CHILD BRONZE 57CMS. HIGH

Synge Museum, Innishmaan

1975 Mrs. Pratt THE 7 CHURCHES ON ARRANMORE PENCIL DRAWING 25.4 x 35.6 MRS. DE . BLACAM

1975 Mrs. Pratt VIEW OF ARAN ISLAND PENCIL DRAWING

Trinity College Dublin

1958 Evie Hone THE FOUR EVANGELISTS - ARDARA CHURCH
GOUACHE CARTOON 3 FT.SQUARE A.F. CONNELL BEQ.

1958 Evie Hone THE FOUR EVANGELISTS - ARDARA CHURCH PENCIL SKETCH A.F. CONNELL BEQ

1958 Evie Hone TWO STUDIES FOR SIDE WINDOWS MRS. A. CONNELL BEQ

Tipperary South Riding County Museum, Clonmel

RHA ⓔ 1998 Rowan Gillespie THE VICTIM BRONZE 25.4 H.

1983 Grace Henry RETURN OF THE POTATO DIGGERS OIL ON CANVAS 34.5 x 39.9 MR. D. GWYNN

RHA ⓔ 1993 Herbert Luther Smith PORTRAIT OF LORD HAWARDEN WATERCOLOUR 54.6 x 39.4

RHA ⓔ 1983 John B. Yeats PORTRAIT OF JOHN O'LEARY OIL ON CANVAS 68 x 35 MISS LILY YEATS

Tyrone Guthrie Centre, Annaghmakerrig

1984 Paddy Graham MAIDA VALE MIXED MEDIA/PAPER 80 x 100

Ulster Museum Belfast

1941 Edward Bainbridge Copnall MOTHER AND CHILD SCULPTURE, GRANITE 102.5 x 99 x 50 E. COPNALL

James Barry BIRTH OF VENUS PROOF COL ENGRAVINGS

1963 James Barry VENUS ANADYOMENE OIL ON CANVAS 75 x 55 MRS A. BODKIN

1973 Thomas Bate PORTRAIT OF LORD CONINGSB OIL ON CANVAS 78.8 x 88.9 FNCI GRANT

1959 Hercules Brabazon VIEW OF SOUSSE, TUNISIA WATERCOLOUR 24.9 x 34.8 DR. R.I BEST

1930 W.H.Clarkson EVENING STAR OIL ON CANVAS 58.5 x 71.2

HLMGMA ⓔ 1956 Jacob Epstein AHMED BRONZE 49.5 x 46.4 x 27

1962 Terry Frost MARS ORANGE AND BLACK OIL ON CANVAS 122.8 x 122.4 FNCI GRANT

1959 Letitia Hamilton FIESOLE HILL, FLORENCE OIL ON BOARD 17.7 X 22.9 DR. R.I. BEST BEQ.

HLMGMA ⓔ 1959 Letitia Hamilton IRISH MARKET SCENE OIL, GOUACHE ON WOOD 30.2 x 42 DR. R.I. BEST BEQ.

1959 Eva Henrietta Hamilton TOBAR PADRAIG, CO. MAYO OIL ON BOARD 21.2 x 25 DR. R.I. BEST BEQ.

1959 Paul Henry LEENANE (1913) OIL ON BOARD 34X 41.2 DR. R.I. BEST BEQ

1962 Roger Hilton JANUARY 1962 OIL ON CANVAS 113.8 x 126.9 FNCI GRANT

1996 William Hollywood MACART'S FORT OIL ON CANVAS 63.5 x 91.4 IN MEMORY OF MRS J.M. MITCHELL

1958 Evie Hone RUIN AT ARDMORE (C,1946) OIL ON WOOD 46.3 x 55.2 DR. R.I. BEST

1959 William Leech SUNFLOWERS WATERCOLOUR 51.1 x 36.6

1973 Andre Lhote FEMME DANS SA CUISINE OIL ON CANVAS 61 x 38.1

1972 Ferenc Martyn ABSTRACT COMPOSITION WATERCOLOUR 29.8 x 40.4

1972 Ferenc Martyn ABSTRACT COMPOSITION WATERCOLOUR 28.8 x 40

1978 George McClelland THE HEALING SCREEN MIXED MEDIA 230 x 220 x 23

HLMGMA (e) 1928 Sir William Orpen MALE FIGURE STUDIES CHALK DRAWINGS/PAPER 62.5 x 48.3 MRS. A. BODKIN

1963 Sir William Orpen NUDE WOMAN PENCIL ON PAPER 32.1 x 18.4 MRS. A. BODKIN

HLMGMA (e) 1974 Sean O'Sullivan GEORGE RUSSELL [AE] (1867-1935) ON HIS DEATHBED (1935)
CHARCOAL ON PAPER 31 x 50.8 MRS.E.SALTERER

1932 Henry Marriott Paget PORTRAIT OF W.B.YEATS OIL ON CANVAS 52.1 x 42.1

HLMGMA (e) 1982 John Piper BLADON (1945) WATERCOLOUR 55.9 x 72.4 NORAH MCGUINESS

1959 Edward Pritchett PIAZZA SAN MARCO, VENICE OIL ON CANVAS 53.3 x 43.2 DR.R.I. BEST BEQ

HLMGMA (e) 1963 Ceri Richards LA CATHÉDRALE ENGLOUTIE (DIALOGUE DU VENT ET DE LA MER) (1962)
OIL ON CANVAS 127 x 127 FNCI GRANT

1962 William Scott UNTITLED (1959) OIL ON CANVAS 86.6 x 111.7 FNCI GRANT

1928 Adam Slade CLIFF END, SUSSEX OIL ON CANVAS 61.9 x 91.4 SARAH PURSER

HLMGMA (e) 1939 Sir Stanley Spencer SCENE FROM THE MARRIAGE AT CANA (1935) OIL ON CANVAS 84.2 x 183.2 LORD MOYNE

HLMGMA (e) 1963 Agostino Tassi LANDSCAPE WITH FIGURES OIL ON CANVAS 35 x 52.3 FNCI GRANT

1956 Hugh Thompson BELFAST LOUGH WATERCOLOUR

HLMGMA (e) 18th century SALVER DUBLIN SILVER 24X24 FNCI GRANT

THE CAVAN MACE FNCI GRANT

THE LOFTUS "GREAT SEAL OF IRELAND" CUP SILVERGILT 50.16 H FNCI GRANT

University College Galway

RHA (e) 1984 Ronald. Dunlop PORTRAIT OF STEPHEN GWYNNE OIL ON CANVAS 51 x 40 MR. D. GWYNN

1981 Mervyn Peake HEAD AND SHOULDERS OF A GIRL PEN/WASH

Waterford Municipal Arts Collection

Sylvia Cooke-Collis RAIN BALLET WATERCOLOUR 34.5 x 51

Grace Henry Oil on

RHA (e) 1969 Jack P. Hanlon MADONNA AND CHILD WATERCOLOUR ON PAPER 79 x 50

1981 Augustus John PORTRAIT OF MRS. PAMELA GROVE PENCIL 54.61 x 36.83 GROVE BEQ.

E. Bernard Lintoff LANDSCAPE OIL ON CANVAS 48.5 x 59

Ferenc Martyn ABSTRACT COMPOSITION OIL ON BOARD 30 x 40

1960 Caroline Scally DUBLIN MOUNTAINS OIL ON CANVAS 30 x 40 J.M. EGAN BEQ.

Gerard Vulliamy ABSTRACT COMPOSITION OIL ON CANVAS 87 x 128

RHA (e) Unknown MULATTO GIRL OIL ON CANVAS 58.5 x 48

Wexford Arts Centre
George Campbell AZTECIANA OIL ON BOARD 43 x 53

1958 Gerard Dillon ABSTRACT COMPOSITION TEXTURED PTG/CANVAS 80 x 67

1979 Stella Frost BRIDGE ON THE NARITIVA WATERCOLOUR 38 x 52 MISS S. KIRKPATRICK BEQ

1970 Evie Hone ABSTRACT PAINTING GOUACHE 27 x 27

Leslie McWeeney GIRL BRUSHING HER HAIR INK ON PAPER 41 x 59 A. STAFFORD KING HARMAN BEQ,

Leslie McWeeney WOMAN AND CHILD DRAWING (INK ON PAP) 21 x 29

1979 E.L.T. Messens AROMATISCK PIKANT MIXED MEDIA 24 x 33 A. STAFFORD KING HARMAN BEQ,

Andrew O'Connor BUST OF COMMODORE BARRY BRONZE/BLACK MARBLE 60 x 30 MRS & MRS JOHN HUNT

Mrs. Pratt DUNBRODY ABBEY PENCIL DRAWING 41 x 27

1979 Anne Stafford King Harman WATERSIDE GOUACHE AND INK 54 x 40 A. STAFFORD KING HARMAN BEQ

RHA ⓔ 1979 Mary Swanzy ABSTRACT GEOMETRIC PAINTING OF PLANTS OIL ON CANVAS 102 x 82 MARY SWANZY BEQ.

RHA ⓔ 1979 Mary Swanzy ABSTRACT GEOMETRIC PAINTING OF PLANTS OIL ON CANVAS 102 x 82 MARY SWANZY BEQ